Portraits of God

Portraits of God

*Word Pictures of the Deity
from the Earliest Times Through Today*

by
Louis Baldwin

McFarland & Company, Inc., Publishers
Jefferson, North Carolina, and London

Also by Louis Baldwin:

To Marry, with Love (with Virginia Baldwin)
Hon. Politician: Mike Mansfield of Montana
Jesus of Galilee
Oneselves: Multiple Personalities, 1911–1981
Edmond Halley and His Comet

BL473
B34
1986

Library of Congress Cataloguing-in-Publication Data

Baldwin, Louis.
Portraits of God.

Bibliography: p.
Includes index.
1. God. I. Title.
BL473.B34 1986 291.2'11 85-43571

ISBN 0-89950-198-2 (acid-free natural paper)

Printed in the United States of America.

McFarland Box 611 Jefferson NC 28640

To Ginnie, with love

Contents

Foreword

This chronological account presents several dozen mental "portraits" of God, but it unavoidably neglects several billion others. Just as no two brains are likely to be exactly the same structurally, no two descriptions of the Deity are likely to coincide in all particulars. Indeed, responses to God may well be as personal and subjective, and as different, as responses to music. And as perishable.

Certain word portraits of God, however, have proved popular and durable enough to be hung in the gallery of history. It is a very commodious gallery, and this catalog reports on only some of the outstanding items in the collection. Another catalog might present a somewhat different selection. But this happens to be the only such catalog currently available.

If God created us in his own image,
we have more than reciprocated.
— *Voltaire*

God is love.
— *1 John 4:8*

Sky Father, Earth Mother

"God," H. L. Mencken once wrote, "is the immemorial refuge of the incompetent."

True enough, though not necessarily as he meant it. We humans as a species are incorrigibly incompetent. Neither our self-congratulatory title of *Homo sapiens* nor our self-satisfying advances in science and technology can conceal this unwelcome characteristic. Incompetence continues to embarrass us with devastating and inconclusive wars, uncontrollable floods, irresistible hurricanes, irreducible crime rates, stubborn diseases, chronic poverty, inscrutable economics—and gnawing fears of still other, unpredictable misfortunes lurking in the shadows just ahead. It is hardly surprising that a president of the United States, widely if inaccurately considered the most powerful person in the world, would regularly respond to his (and our) appalling problems by turning wistfully to prayer.

Prehistoric humans must have found their environment likewise beyond their competence. This is clearly the case in existing cultures that we somewhat gratuitously call "primitive." If the analogy with these cultures is valid, prehistoric humans reacted to their unmanageable problems with anxious responses not unlike the president's. Indeed, one of the oldest and most basic names for God is "the one to whom prayers are addressed."

Our primordial ancestors must have thought of this "one" as something besides a void, but beyond this we can only conjecture. The things they left behind—spear points, hand scrapers, smoke-blackened caves, animal bones—tell us something about how they survived but not about how they thought. We must assume from

1

analogy that they vaguely envisioned a mysterious something behind the thunder and lightning, the sunshine and rain, the wildflower and volcano — or, more probably, a mysterious some-*one*, since a phenomenal amount of lively power was continually on display, power of a superhuman kind likely to impress people who were still learning to use tools and make a fire. Further, the power expressed itself in a mind-boggling variety of wonders, so that any idea of a unique, almighty Someone could well be expected to dissolve, with time, into myriad fantasies.

The earliest of these fantasies seems to have arisen from a universal experience of mammals, that of growing up. More than other animals, mammals in their early years are notably incompetent and extraordinarily dependent on their parents, and this dependence must enter strongly into the programming of their adult behavior. So it must have been with our ancestors who, with their more enterprising imaginations, could be expected to seek replacements for their parents among the natural forces which, like parents, both sustained and buffeted them. This may be why Freud wrote with such typical assurance that everyone's notion of God is based on that person's unconscious notion of his or her own father. And it may also be why we find the concepts of Sky Father and Earth Mother so common in the traditions of existing primitive cultures and in the earliest historical records.

High Gods

Such concepts can be seen, throughout reports on "preliterate" people, in what many cultural anthropologists call "high gods." These generally are beings that transcend the clusters of less imposing deities. Thus for aboriginal tribes in southeastern Australia such as the Kulin, a supernatural being called Bunjil resides in the sky. He is honored affectionately as "our father" and is considered the maker of things and first teacher of ancient ancestors. In Polynesia the transcendent god is called Io, although the Maoris, in a variant of a Hebrew custom, never utter the name except under the open sky. Scholars know very little about Io because Maori priests have always refused, out of fear, to discuss the subject with fair-skinned intruders.

Among North American Indians the Great Spirit appears under many names. The Delawares give thanks to a supreme Mani for the gifts of nature — which are distributed, however, by subordinate spirits, since the supreme Mani enjoys a remote executive suite in the twelfth (and highest) level of the sky. The Dakotans pay their first respects to Nagi Tanka, or The Blue Sky, besides their additional insurance premiums to a host of divine agents responsible for various aspects of nature. The Pawnee worship Tirawa atius, who, although referred to as The Father Above, is the remote and impersonal power behind natural phenomena.

In South America, the Kabagas of Colombia revere a Mother of All, including the sky, the sun and rain, and growing things. For the Aspinaye tribe of Brazil, the sun is creator of the world and father of the people, for whom he shows a very personal concern.

The high god of the Kikuyu tribe of eastern Africa is Ngai, the supreme creator and provider who lives in the sky. Because Ngai keeps his distance — preferring mountaintops, for example, during his rare visits to earth — the people pray to him only at times of intense personal crisis or important community decisions. To the Isoko people of southern Nigeria, Cghene is the supreme creator in the sky who gives them the sunshine and rain and who reveals his anger with thunder and lightning. Because he also is remote and rather formidable, prayers are offered to him only in the presence of a special pole, taller than a man, erected and consecrated in the hut of the oldest member of the family. Even more inaccessible is Nzambi, the sovereign god of the Bakongo tribe of the Congo River, to whom the people offer no worship because he has no need of it.

These few samples typify a very long list. Doubtless they give us an idea — we have no reason to think otherwise — of our prehistoric ancestors' ideas about the active force behind the wonders they observed. Whichever came first, monotheism or polytheism, our earliest forebears at some time must have glimpsed something, or someone, beyond the welter of animal spirits, ghosts, pixies, sprites, nymphs, satyrs, hobgoblins and assorted godlings that peopled their fertile imaginations.

The Earliest Scriptures

This hypothesis received no little support from the earliest scraps of writing uncovered by archeology. They tell us, though often obscurely, of a unique, supreme, sometimes sexless and impersonal divinity towering above the busy godlings of hearth and health, of crops and crafts, of bards and battles, of laments and erotic love. It is the living power of the sky, of the sun and lightning, of rain and thunder, of life itself.

These earliest records, some sixty centuries old, have been found in the ruins of ancient cities, where the art of writing must have developed. Each city had its own supreme deity. Because the cities grew separately at first, with relatively little commerce and other communication among them, their various deities, whatever their basic similarities, had various names. This seems to have led naturally to conceptions of them as distinct beings, rather than different aspects of one being. And so, with human aggression already in full flower, the rise and fall of a city determined the fate of its god. The supreme god of a conquered city was quickly relegated to an inferior, often fetch-and-carry role.

Enlil & Co.

In the ancient city of Nippur, in the fertile lower valley of the Tigris and Euphrates rivers in Mesopotamia, the people worshipped Ninib, whom they associated with the sun. When the Sumerians invaded the valley and captured Nippur, their great god Enlil replaced Ninib, who was demoted to the position of Enlil's No. 1 son. Enlil, god of winds and heir of the distant sky god Anu, supported by military clout and by a durably vigorous priesthood, was destined to maintain an exalted status for the next thousand years.

At times, however, he had to share that status with the gods of other important and pushy cities. Ea (sometimes alias Enki) was the god of Eridu, a city which promoted his fame for flood control and other kindnesses throughout Mesopotamia, and eventually succeeded in hoisting him almost to Enlil's level. The city of

Uruk was even more successful with its candidate, Anu, who jost-
led his son Enlil off his supreme perch and even replaced him for
a while. All this unseemly pushing and pulling ended in a com-
promise, with Enlil recognized as lord of the earth, Anu as lord of
the sky, and Ea as lord of the waters. Behind these three, however,
there lurked the shadowy goddess Nammu, in charge of the
primeval waters. Apparently with her support, the trio maintained
their uneasy symbiosis until Marduk of Babylon appeared.

Marduk vs. *Ashur*

Marduk, the sun god of Babylon, cast a very feeble light in
Mesopotamia until about the 18th century B.C., when his city, led
by the celebrated Hammurabi, burgeoned into a veritable em-
pire. As the Sumerian trio faded into the wings, he assumed most
of their titles, their roles, and even their histories. His diligent
priests saw to it that the other gods either disappeared or were
given lowly, unobtrusive assignments. (Shamash, the sun god of
the city of Sippar, for example, was put in charge of Ham-
murabi's famous law code.) Yet Marduk's position of almost ab-
solute supremacy was short-lived.

A mighty rival arose as the city of Ashur, to the north, ex-
panded into the great Assyrian empire. The city's sun god, also
named Ashur, developed into the supreme god of the empire, and
his formidable influence proved to be more than Marduk and his
priests could comfortably handle. In the ensuing rivalry, no
quarter was given, no compromise ever reached. The two gods
seesawed indecisively for the next thousand years or so, their
relative status at any one time depending on the luck of the sword,
until finally they both succumbed to the might of the Persians'
Ahura Mazda.

Beside them and their predecessors from the beginning,
reaching back into prehistoric times, was the earth-mother God-
dess Ishtar, source and symbol of fertility. With the eager coopera-
tion of the sky god under his various names and guises, she was
responsible for maintaining the mystical spark of life. With
reproduction as her specialty, she quite appropriately survived

long after her Mesopotamian contemporaries, finally ending her
long career in the Götterdämmerung of the Roman pantheon.

The Durable Re

In the meantime a similar game of musical thrones was being
played some 800 miles to the southeast, in the valley of the Nile.
But there was a difference in the name-change routine: as local
deities grew dominant and then subsided, they often were joined
with the perennial sun god, although they never quite replaced
him.

In Egypt the water of life comes from the earth in the form of
seasonal flooding, rather than from the sky in the form of rain.
This may explain the role reversal of earth god and sky goddess.
The former, Geb, ancient father of the gods, in collaboration with
the latter, Nut, sired the greatest and most enduring of the Egyp-
tian gods, the sun god Re, whose supremacy was never quite
equaled by Osiris, god of the floodwaters (and, analogically, of
spiritual resurrection).

As the power of various cities along the Nile rose and fell, so
did that of their various local gods, but Re, supported by a
priesthood skilled in entrenchment, seems to have survived almost
without interruption, partly by absorbing his most formidable
competitors. Thus the gods Horus and Atum, both of Heliopolis,
became identified with Re, the latter for a while receiving top bill-
ing in the title Atum-Re. Ptah, god of Memphis and patron of ar-
tisans, also enjoyed this cosy intimacy for a time before his final
disappearance. This practice of assimilation culminated, in the
16th century B.C., in the last of the great mergers, when Thebes
extended its absolute rule over all Egypt and much of the Near East
as well. Its supreme god was Amon, and it was Amon-Re who
ruled virtually unchallenged for the next thousand years, until
Egyptian power succumbed successively to the military per-
suasiveness of Persia, Greece, and Rome.

The rule of Amon-Re suffered one brief, peculiar interruption
in the 14th century. During his reign of about seventeen years, the
pharaoh Akenaton (husband of the fabulous Nefertiti) imposed a

strict monotheism on Egypt in honor of Aton, whom he introduced as creator of the world and supreme ruler of mankind. In his fervor he ordered all other gods relegated to oblivion, including Amon-Re, whose name he directed to be obliterated from all religious monuments. This was too much for the priests to stomach, and they were joined by the military vested interests, who considered Aton insufficiently bellicose. And so, when the visionary pharaoh died, Aton died with him, and Amon-Re again reigned supreme.

The Vedic Varuna

The prehistoric people of India have faded into obscurity, leaving behind the usual fertility figurines and phallic symbols but no clear evidence of any ideas arising from above the waist. What gods they had were easily shouldered aside, in about the 15th century B.C., by the complex, sophisticated pantheon of the conquering Indo-Europeans from the northwest, who brought with them gods and goddesses of dawn, rain, fire, wind, lightning, and countless other things, including a god of intoxicating liquor. The Vedas, India's ancient scriptures, teem with such deities.

Far above this busy crowd, however, hovered the supreme sky-father Dyaus and later his heir Varuna, symbol of light and universal order. Varuna's dominance over the renowned sun-god Mithra gave the earth the reassuringly recurrent seasons of the year. All-powerful and all-wise, he was lord of morality, dispenser of justice to mankind. Since he saw everything, people could not hide from him either their whereabouts or their actions, however furtive. He was everywhere, in every drop of seawater, in every drop of rain. With talents like these he was able to reign for many centuries, until the philosophers depersonalized him, whereupon he disappeared. It takes a sturdy god indeed to survive the philosophers.

T'ien

Because archeology came late to China, the prehistoric inhabitants are hidden behind a veil even darker than elsewhere. But

the little evidence so far uncovered, together with the earliest written records, suggests a familiar pattern of rivalry at first among the supreme gods of various cities and regions, and then their consolidation into a single overlord.

The oldest written sources reveal that shortly after 1000 B.C., when the Chou dynasty succeeded the earliest known dynasty (the Shang), the Chou sky god T'ien was set up in solitary splendor above the countless other deities having special responsibilities or merely parochial roles. Since the Chou dynasty lasted until 256 B.C., there was plenty of time for T'ien to grow. As the Parent of Mankind, he became the arbiter of social relationships and obligations. He answered prayers, though only those of the righteous, or at least the ostensibly righteous. He rewarded good conduct and punished bad, for both individuals and communities. He showered blessings on the people, but sometimes he could be displeased and cause them frightful suffering.

During the last four or five centuries of the Chou period, the fabric of Chinese society began to fray badly. Famine, pestilence and especially war racked the land, and the sufferings of the people outweighed their blessings. Turning from an apparently heedless T'ien, they addressed their prayers to their more neighborly minor gods. Meanwhile the philosophers began speaking of T'ien in ever more impersonal, cosmic terms, perhaps partly to relieve him of responsibility.

The most famous of these philosophers was Confucius, whose portrait of T'ien, if it can be called that, will be considered later in these pages.

The Olympian Zeus

The accounts of the Greek gods that we find in the literature of about the 8th century B.C. strongly resemble our own gossip-column reports on Hollywood celebrities. These gods and goddesses on Mount Olympus were a boisterous, roisterous, uninhibited lot, ardently dedicated to sportive eroticism and martial tumult. Their high god Zeus was an incorrigible rake who used his position to promote opportunities for satisfying his voracious

sexual appetite, which was the talk of much more than the town.

The source of this celestial jet set seems to have been the western branch of those Indo-Europeans who also had migrated eastward into India with their overpopulated pantheon. Their sky god Varuna apparently was transformed into the oldest of the Greek gods, the sky god Uranus, husband of the earth mother Gaea. These two spawned a large family but not a very happy one. Uranus was murdered by his youngest son Kronos, who in turn was dethroned and exiled by *his* son Zeus. The outcome of this and some other family difficulties was that Zeus assumed the perks and powers of his grandfather.

The Romans, in conquering Greece, took over the Greek pantheon lock, stock and Olympus, changing nothing but the names. Gaea became Terra; Kronos, Saturn; and Zeus, Jupiter. In general the Olympian rascals were otherwise allowed to keep their identities, although under the Romans, who were less imaginative and playful than the Greeks, they grew considerably more staid and respectable.

In neither Greece nor Rome were they taken seriously by anyone who thought about them seriously. The Roman emperors used them as exalted flunkies in state ceremonies, and a murmuring lip service was paid by the citizenry in lieu of insurance premiums. And the might of the Roman empire could not save them from finally being blown away, like so many dog-eared playing cards, by the breath of a convicted criminal executed in the insignificant little province of Judea in Palestine.

What historians call the four major cradlelands of civilization—in Mesopotamia, Egypt, India and China—thus entered into history with substantially similar ideas of a single, supreme God. Dwelling mysteriously in the sky, he (or occasionally she, or it) was creator, provider, and judge, an ineffable spirit of awesome power on which mankind depended for survival. Divine underlings, burdened with responsibilities for the daily nitty-gritty, operated only through his, her, or its power and authority.

Today the names given to these concepts of God have largely

passed into ancient history, although the fundamental qualities attributed to their bearers can be seen in successors who live today. It is to these successors that we must now turn our attention.

Ahura Mazda

In 480 B.C. the Persians tried to extend their mighty empire westward, grimly bent on dominating the European continent. If the stubborn Greeks had not given them a famous drubbing and a ticket home, Ahura Mazda might have become the God of Western civilization. Instead, he is the God of about a hundred thousand Parsis living in the Bombay region of India, descendants of Zoroastrians who fled Persia after the Moslem conquest in the A.D. 600's.

His origins are hidden in the mists of ancient history. He seems to have been the most distinguished of an undistinguished lot of urban deities until the seventh century B.C., when the prophet Zoroaster strode exuberantly upon the scene and eventually, with the armed support of a converted local ruler, transformed him into the benign superdeity of all Persia. Ahura Mazda, All-Knowing Lord, may have been selected for his starring role because of an association with Varuna, the Indo-European sky god who had risen to similar heights in northwestern India. But he was confronted with a sticky problem that apparently never troubled Varuna or his adherents, at least not enough to prompt any serious attempt to solve it.

Zoroaster did try to solve it. The "problem of evil" is as old as history and as new as an article in this month's issue of a religious journal. How can there be evil in a world created and governed by an all-knowing, all-powerful, all-good and benevolent God? Zoroaster's answer, more imaginative than logical, was that Ahura Mazda, though all-knowing and all-good, was temporarily less than all-powerful. His power was, lamentably, limited by that of

a rival deity, Ahriman, the epitome of evil. This dualism was not necessarily a revolutionary idea, since the old Persian religions seem to have included an ancient belief that all good things came from the bright sky and all evil things from the dark regions underground — a belief that Zoroaster must have found very useful in getting the Lord Mazda off the hook.

But to this primitive idea Zoroaster added an element of hope, which may largely account for the durability of his creed. The battle between good and evil, he explained, was only temporary. It was inexorably destined to end, after twelve thousand years of unpleasantness, in a final victory for the forces of good. Ahura Mazda would then reign in uncontested splendor over a paradise filled with the jubilant faithful.

Drawing strength from this reassuring fancy, Ahura Mazda gained enthusiastic acceptance as the ultimate creator, the supreme divinity — spiritual, timeless, unequaled, all-knowing, powerful, joyful, sacred, unblemished, just, benevolent. He was the source of happiness for those who acknowledged his sovereignty and conducted themselves according to the rules proclaimed through Zoroaster. Since Iran was a land of agriculture and domesticated cattle, many of the rules had to do with conscientious farming and ranching practices. (The fruitful earth was considered so holy that the dead were left exposed on raised platforms rather than buried, to avoid contaminating it.) But other rules had the ring of a more general ethical code: guard your reputation, respect authority, avoid malicious thoughts, repent your sins — and, uniquely, never mistreat a dog.

No religion can survive merely on ethics, of course. A remark of Ahura Mazda's to Zoroaster, to the effect that libations pleased him, naturally encouraged the professional priesthood to develop elaborate ceremonials for channeling community worship and thereby promoting their trade. This in turn kept alive many of the old deities, though in subordinate roles — gods and goddesses of wind, rain, fire, metals, but also of truth, obedience, good intentions, righteousness. This moral element, as opposed to simple supplication, may have been due to the resurgent influence of one of the oldest gods, Mithra the upright, who became a close rival of Ahura Mazda, though never his equal.

Since the Moslem conquest of Persia, Ahura Mazda has dwindled to a sectarian god of the expatriate Parsis, who have recently tended to forsake their dualistic views, preferring to ascribe the existence of evil to the machinations of humanity. He retains, however, the noble qualities that characterized him when he dominated a large and important segment of the ancient world.

Brahman

The ancients looked upon the universe and found it wanting, just as most of us do today. For all its vast splendor, for all its wonders, it is not self-explanatory. And the human mind, as it has grown in experience and knowledge, seems to have developed a compulsive need for explanations.

Yet an explanation for the universe is not easy to come by. Because it changed from day to day, and indeed from microsecond to microsecond, the universe is hard to conceive of as having had no beginning (as suggested in the Afterword). Then what preceded it? Something timeless and unchanging, yet able and willing to create it? This question, as the human animal emerged from its preoccupation with survival and lucky individuals acquired some leisure time for contemplation, received more and more attention. The attention has never been enough, however, to dispel the mystery of the Timeless acting within time.

In India the attention gave rise to the notion of Brahman, which stresses timelessness at the expense of activity. This was the universal One, unchanging, infinite, benignly inactive, mysteriously all-pervasive, into whose being a human spirit could be absorbed as an exhaled breath is absorbed into the air. It was a God well suited to Indian mysticism, which owed and gave so much to the ultimate exercise in blissful impassivity, the meditative trance.

The vast multitude of godlings remained alive and well at less sophisticated levels of Indian society, thriving under the tolerance that generally has characterized the Far Eastern religions. Brahman was much too impersonal and remote for popular use in everyday chores, or even for help in achieving, through

continual rebirths, the ever happier status of life that would lead finally to absorption into the Infinite.

This tension, between God and gods, was somewhat relieved by accommodation when three of the minor gods were ingeniously transformed into aspects of the One, generally described as Brahma the Creator ("Brahma" being the masculine form of the neuter "Brahman"), Vishnu the preserver, and Siva the destroyer. Of these three, Brahma, as creator of a possibly uncreated universe of endless cycles, proved the least durable. He was especially vulnerable to criticism, since the imperfections and suffering in the world suggested a measure of incompetence. He seems to have receded into the background rather early, and rather diffidently.

Vishnu's roots reach back to the times before the coming of the Indo-Europeans (a reason, perhaps, for his having a thousand names). From the beginning he seems to have been an attractive god: responsive, cooperative, solicitous, undemanding (he did not require sacrifice, for instance). By the time of Brahman's emergence, he and another tribal god, Krishna, had achieved such importance among the common people that the intellectuals, mystics and priests had to give them special recognition. Both have kept their exalted status, with Krishna in a technically subordinate role.

Siva's origins reach at least as far back as Vishnu's but, unlike Vishnu, he seems always to have had a baleful streak in his character. A god of plenty, health and life, he was also a god of scarcity, disease and death, alternately sensual and ascetic. Unlike Vishnu's joyful associate Krishna, who would take bodily form to do works of mercy, Siva's dour associate Rudra appeared in disagreeable forms like lethal thunderbolts and disastrous winds. Although with the passage of centuries Siva's better nature seems to have drawn more attention, the division has remained, perhaps not so much to solve the problem of evil as to acknowledge it.

Interestingly, his wives share in the division. Some, like Uma and the extraordinarily shapely Parvati, are happy, beautiful, unwaveringly benign. But others are less appealing. Durga is a goddess of many arms, the better to wreak havoc with. Another is Kali, a harridan sporting such decorations as human skulls, severed hands and bloody weapons, the lady who cavorts on dead

bodies and sometimes consumes them. These and other wives, with their roots also in prehistory, are still very real to many Indians and at times are seen, in art and myth, as wearing the pants in the family.

Siva's offspring are many, too many to be enumerated here. But one is worth mention in passing: Ganga, who in liquid form is the sacred river Ganges.

In about the ninth century A.D. the tension between the impersonal God of the intellectuals and the very personal gods of the people entered more forcefully into the philosophers' discussions of the sacred scriptures. The sage Sankara, for instance, presented Brahman as wholly impersonal and inaccessible to human thought and as incorporating all reality, so that human perceptions were dream-like illusions. For popular consumption he did offer a faintly personal deity, Isvara, but his grudging concession was totally inadequate to satisfy popular demand. Most people, after all, need something to hope for, and someone to take hope from.

Some three hundred years later, the philosopher Ramanuja took quite a different tack. Working from the same scriptures and religious traditions as Sankara, he presented Brahman as supremely, transcendentally personal, encompassing all reality yet accessible to human knowledge, sometimes in visible form. Significantly, the human soul, when finally released from this mortal coil, would forever abide in Brahman, without desire but in conscious contentment.

And so, over the intervening centuries, philosophers and mystics have come and gone, their ideas intermingling in the ebb and flow of human reflection, their visions of God competing with and modifying one another in India's climate of tolerance. Later centuries brought outside influences, notably the fiery glow of Christianity and Islam, and the cold light of Western science. Hindu thinkers, unrestricted and unimpressed by any dogmatism, accommodated the new ideas and absorbed them. For many, Brahman became ever more the infinite, ineffable, impersonal One; Vishnu became the more imaginable, accessible, personal preeminence; and Krishna, usually with his wife Radha, became

the savior incarnate, the mediator for suffering mankind. For others, Brahman alone is divine, somehow personal but very remote, benign yet unforgiving (permitting salvation only through the cycles of rebirth), all-pervasive yet unapproachable. For still others, Brahman has dissolved into the sum of human souls.

Hindu conceptions of God, with all their fluidity and subtle variety, resist any easy generalizations. Their history does share, however, in the universal contest between aloof monotheism and neighborly polytheism. In India this rivalry seems to have found some peace in an uneasy compromise, with a colorful polytheism tolerated in a highly absorbent pantheism. Provincial godlings may be pretty small potatoes when compared to the All-Pervasive Infinite; but, as with Christian angels and saints, it is very comforting to pray to them.

Nevertheless, they are not enough. Here and there, in more recent times, Indian voices have been heard singing—as in the poetry of the philosopher and Nobel laureate Rabindranath Tagore—of Brahman as the ultimate in spiritual love.

The Buddha

In India in the sixth century B.C., Hinduism, like religions before and after it, was largely in the grip of a vested interest, a professional priesthood devoted, not unnaturally, to self-perpetuation. Supported by their claims of influence with the finite yet superhuman gods, the priests characteristically prescribed elaborate rites for approved forms of supplication, with themselves as indispensable mediators. The system did not seem to work spectacularly well in promoting happiness and dispelling misery, but the people had no basis for comparison and could come up with no viable alternative.

Then a young man named Siddhartha Gautama (563?–483? B.C.) offered a viable alternative. A young high-caste aristocrat living in northern India, enjoying the good life, he became troubled by the misery in other lives, especially in the lower castes of the rigidly structured Indian society, and by the apparent futility of petitioning fanciful godlings through a protocol of mediation. Human misery, he concluded, arises out of human desire. To eliminate one's misery, therefore, one must eliminate desire, cultivating detachment. And one can do this for and by oneself, through a process of disentanglement leading to the ultimate "nirvana" of annihilation and happy absorption into the Infinite. This final freedom awaits every follower of his "Eightfold Path" of righteous living.

Regarding the Infinite, however, Gautama was adamantly reticent. He saw his function as leading people to God, not describing God to people. God was indescribable anyway, and quite beyond mere human comprehension. To demands from his

18

followers for a dossier on Ultimate Reality he turned a gently but stonily deaf ear. From his viewpoint, this silence may have been a mistake. Undoubtedly it was partly responsible for the division of Buddhism into a simple, rather spare Hinayana form and an elaborate, fanciful and much more popular Mahayana form. He clearly left too much to irrepressible human imagination.

During his life he made no claim to any kind of divinity and firmly declined any such honor from some of his more breathless followers. He accepted the title of Buddha, "Enlightened One," but he seems to have been genuinely concerned with mankind's path to freedom from suffering, not with any path to his own or anyone else's deification. Nevertheless, not very long after his departure into his own nirvana, he became veiled in the mists of inventive legend. Virgin-born, credited with the strength of 10^{10} elephants, he was quickly surrounded with a host of more or less buddha-like divinities.

Buddhism, particularly Mahayana Buddhism, manifestly under the romantic influence of Hinduism, incorporated countless godlings for popular consumption, since Gautama had been quite tolerant of such friendly helpmates for employment in everyday living. Going beyond this priestly intervention, the Mahayana philosophers gave Gautama a life history of as much as 54×10^{16} world cycles, during which he approached his final status as the supreme Buddha — whereupon he took human form to bring salvation to suffering mankind. This act of compassionate love — Buddhism has been described as second only to Christianity in its exaltation of love — led to the notion of the Bodhisattvas, followers who emulated the Buddha in careers of similarly selfless love in their long quest for nirvana, for what came to be known as Buddhahood.

In this idea of Buddhahood the philosophers found their Absolute, the Dharmakaya, the essential being shared by all Buddhas as waves share the substance of the sea. In its incomprehensibility and inaccessibility, however, it was not very satisfying. So a kind of trinity emerged, including as well a personalized form of the Absolute suitable for human worship (the Sambhogakaya) and an incarnate form suitable for human salvation (the Nirmanakaya). With time the various Buddhist sects developed several extrava-

gant versions of this system. Buddhist philosophers in Nepal, for instance, came up with a quintet of such trinities, one each for north, south, east, west, and the zenith. And godlings multiplied like rabbits safe from predators: an early Mahayana scripture accounts for at least 10^{16}, and another describes a paradise containing 1296×10^{24} Buddhas. It may be significant that the decimal system was invented in India.

All this probably was inevitable. The fate of every prophet's message is dilution. Gautama, the only historically verifiable Buddha, who had preached reliance on self for salvation rather than on visionary deities, soon after his death had more company than he could ever have anticipated. His shadowy, ineffable One retired behind a dense cloud of the many. For philosophers, the many were merely manifestations of the One, but priests and people seem never to have found this notion very convincing.

Buddhism failed to survive in India, where it was effectively swallowed up by a Hinduism that it had largely reformed. It spread, however, into Southeast Asia in its Hinayana form and, prodigiously, into China, Korea and Japan in its Mahayana form. In the process it fragmented into many sects. Although it usually is not thought of in association with sectarianism because of its genius for impassivity and tolerance, the sects have developed nonetheless, and their conceptions of the One range from a kind of vaguely affirmative void to an all-pervasive presence infusing, or consisting of, the universe, luxuriantly supplemented by a vast array of assorted godlings.

To a modern Western mind, long accustomed to the mundane rigors of logic and to the notion of a more or less anthropomorphic God, mystical Eastern conceptions of a more or less amorphous God seem untidy if not totally inscrutable. Buddhism offers no exception. Yet its visions of God, however variegated and diffuse, have sustained billions of adherents over more than two thousand years.

The Tao

A near contemporary of Gautama Buddha was the Chinese sage Lao-Tzu (c.604–531 B.C.), who introduced the Tao into the history of God.

It did nothing to clarify things. Even Confucius found the idea quite baffling. "The Tao" is often translated as "The Way," in the sense perhaps that Jesus speaks of himself as "the way" in the English Bible. Some Chinese translations of St. John's gospel start with "In the beginning was the Tao, and the Tao was with God, and the Tao was God."

The Taoist scriptures define the Tao as, among other things, indefinable. It is changeless and impersonal and probably unconscious, yet it may be thought of as the mother of the universe. It is supreme, yet so are heaven and earth and mankind. It is like water, beneficial but not aggressive, filling spaces not occupied by other things. It is totally passive, yet it is the life force, the principle of existence. It is the supreme deity of China, T'ien, in the latter's most ethereal, attenuated form.

But no, not quite, perhaps: for all its passivity, it brought forth the One, which brought forth two, which brought forth three, which brought forth the universe. It also created the dichotomy of yang and yin, the active/passive, assertive/submissive, light/dark, warm/cold, dry/wet, male/female duality of the universe. All things, depite their mind-boggling variety, have the Tao in common; yet it is the Tao of each thing that makes it what it is.

This was the God of the intellectuals — Chang-tzu and Hsun-tzu of the third century B.C., for example, and Wang Ch'ung of the first century A.D. Ordinary people, however, held on

doggedly to their favorite godlings while promoting Lao-Tzu up the ladder of divinity. Official rituals included prayers of supplication for divine protection and generosity, and even the scholars often addressed T'ien-Tao in terms suggesting that a benevolent response would be warmly appreciated. Whatever the theories, such practices remained rooted in popular custom, modified only superficially when the spread of Buddhism introduced a different nomenclature.

Despite this plebeian embroidery, dilution and neglect, despite all the mystical ambiguity (reminiscent of the Zen cliché about the sound of one hand clapping), the concept of the Tao has survived for 2500 years. Its mystical ambiguity, indeed, may be a major reason for its durability. What cannot be grasped will often continue to be pursued.

T'ien and Confucius

By the sixth century B.C. religion in China had pretty well settled into a vast diversity surmounted by an indistinct unity. The diversity was provided by the overworked godlings, usually specific in locale and function. The unity was provided by the ultimate, all-pervasive One, viewed from two aspects: the distant, impersonal T'ien and the more imaginable, even fatherly Shang-ti, an exalted survivor from the early Shang dynasty. Shang-ti could be prayed to, but only by the emperor, who was considered his direct descendant. Thus official religious ceremonies, conducted by the head of state with the inevitable horde of subalterns, combined echoes of ancestor-veneration with a kind of formal diplomacy. Common folk prayed to their own familiar deities, usually including the spirits of departed relatives.

This mixture was heavily laced with the dualism of yang, the source of good spirits, and yin, the source of evil spirits. These forces infused every soul and permeated the environment. Everyone interested in reasonably comfortable survival spent considerable time eagerly importuning the former and anxiously propitiating the latter. Ceremonial beating of drums and kettles and the lighting of protective torches at night, for example, were considered very effective methods of appeasement.

Confucius (c.551–479 B.C.) evidently found all this unobjectionable but also uninspiring. Like Gautama, he would not concern himself with the nature of God. His first, fleeting fame came to him as a management expert in government administration; his interests were never so much in theology as in the political and

social arts and sciences. He also was a scholar devoted to Chinese
literary classics, and as such he had too great a sense of cultural
continuity to desire any overturning of the religious establish-
ment.

He did want to invest it, however, with a sense of social obliga-
tion and propriety, of duty to oneself and others, and in this he
greatly succeeded. He even formulated a predecessor of the
Golden Rule, modeled partly on a Taoist principle of answering
injury with kindness. (He felt it should be answered with justice.)
He subscribed to the importance of love, but the love he taught was
human rather than divine. Although in some sense he seemed to
think of himself as carrying out the will of T'ien, he spoke of that
One as being totally uncommunicative. "Does Heaven speak?" he
once asked skeptically.

In this respect it is probably significant that he reportedly used
the name "Shang-ti" only once in his public life, perhaps in-
advertently. He much preferred to use the name of the ineffable
T'ien as the source of his rules for good behavior, for he considered
the nature of man and the universe to be fundamentally good. He
seems to have accepted T'ien much as Euclid accepted certain ax-
ioms as the basis for his mathematical constructions. But he was
not about to be embroiled in any discussion of just what T'ien con-
sisted of; like Gautama, he considered such discussion futile and
rather disedifying.

As for his own status, he of course thought of it as unequivo-
cally human. Thus it is ironic that he, like Gautama, was eventu-
ally deified. The process was glacial but inexorable. About three
hundred years after his death a Chinese emperor made the first
move by offering a sacrifice at his tomb. Within another century
sacrifices were being offered to his spirit regularly, by imperial
command. Temples dedicated to his honor sprang up all over the
empire. In 1370, when the emperor Hung Wu stripped all the god-
lings of their divine titles, Confucius kept his. At the beginning of
the twentieth century, devotions to him were officially given the
most exalted status.

Only with the coming of republicanism and then Communism
did his official status suffer a demotion. But the demotion, of
course, affected only his *official* position.

The religions of the Far East contributed a great deal to the history of religion but much less to the history of God — as seen, at least, through Western eyes. Their general acceptance of the impersonality, passivity, indistinctness, all-pervasiveness, and utter incomprehensibility of the One, their easy resort to ready-made godlings for practical help, their leaders' reluctance to discuss the One and willingness to recognize the many, their essentially indiscriminate tolerance and absorption of conflicting notions into a kind of uneasy agnosticism — such characteristics were inherently limiting factors in any effort toward a systematic theology. The people, and even the scholars, just were not sufficiently interested.

It has been a much different story in the West, of course.

Yahweh

From the beginning the God of the West has offered sharp contrast with the dimly nebulous, impersonal, inert and uncommunicative One of the Far East. He — to use an arbitrary English pronoun, to be distinguished chiefly from "it" — he has of course been nebulous, but not dimly so, and he has consistently been highly personal, tirelessly active, and overwhelmingly communicative. According to the ancient record, he was a jealous God, intolerant of all serious competition, and an emotional God, capable of harrowing rages, disastrous vengeance, and fatherly kindness.

He was also a God of covenants, of quid-pro-quo contractual arrangements. In return for their loyalty, he would lead his people to a land of abundance, rescue them from slavery, feed them in the desert vastness, bring them victory against their formidable enemies. And in return for their disloyalty and neglect, he would abandon them to their enemies' vengeance or sometimes inflict them with his own.

His origins are typically obscure, lost in the deep shadows of thirty centuries ago. He first appears in history as the god of a Semitic tribe then wandering generally westward from the city of Ur, on the northern shore of the Persian Gulf, toward the southeastern shore of the Mediterranean Sea. Led by a patriarch known to us as Abraham, these people came to be called Hebrews, apparently from a semantic connection with their crossing of the Euphrates River. Ever in search of food and water, as well as natural fodder for their livestock, they settled for a while near a town called Haran. Here the god of Abraham offered him and his

followers a promise: if they would trust him above other gods, such as the sky god El and the storm god Baal, he would lead them to the more fertile land of Canaan, in what is now called Palestine.

This he did, but their arrival proved ill timed since Canaan was in the grip of a famine, which forced them to continue into Egyptian territory. After an uneasy sojourn there, they returned to Canaan when it had recovered from the drought. Before long Abraham had another conversation with the Lord his God. (In the Hebrew records, as the authors grew more thoroughly awed by this God, who seemed so much more competent than his rivals, they took to using the honorific "Lord" as a form of address and reference, a term that fills their scriptures. It is not a unique title, of course, but in this case it was also a device for avoiding the supremely holy name.) In this conversation the Lord offered a more formal contract: in exchange for right conduct, for obedience to his law, Abraham's followers would be granted a boon held dear in ancient cultures, a vast multitude of descendants — who, the Lord promised, would be "my people." A formal rite of circumcision was established as a sign of membership, at least for males. This was only a symbol, however. Membership in reality consisted first in "doing what is right." This was a kind of distinction between form and substance which the Hebrews, like the rest of mankind, would have trouble keeping in mind.

The ethical requirement here was not unprecedented; it may well have been influenced by the Hebrews' early contact with the bracing legal climate of Hammurabi in Mesopotamia. Indeed, within their own tradition the Lord had earlier entered into a similar, if vaguer, agreement with Noah after the Mesopotamian deluge, promising a fruitful and unflooded posterity but threatening punishment for murder — because, he added significantly during the conversation, mankind was "made like God."

This resemblance was only partial, to say the least. Several hundred years after Abraham, the Hebrew Moses was greeted by a voice emerging from a burning bush and announcing itself as the god of his ancestors. Moses had been chosen, the voice explained, to rescue the Hebrews who had fled to Egypt during a famine and were now being held there as slaves. Moses, perhaps the most

reluctant leader in history, countered with several questions and objections, all overruled or accommodated. Among his questions was that of identification: if he was to tell the Egyptian pharaoh that he had been sent by a God, what name should he give? And the voice replied that he should give the name, "I Am" (or perhaps "I Am That Am," or even "I Am and Will Be," depending on the translator). In Hebrew, "I Am" sounds like "Yahweh," or, as transliterated later, "Jehovah."

This is a surprisingly sophisticated answer in a context that otherwise presents the Lord as a deity with very human emotions and very provincial concerns. Its emphasis on transcendent existence was worthy of the most metaphysical concepts proposed in the Far Eastern groves of academe. Finding it here is almost like finding the formula $E = mc^2$ etched on an ancient Sumerian tablet. Yet it was to prove adamantly durable, the unbreakable thread linking the early Yahweh to the multifaceted God of the atomic age, connecting the God of Moses with the God of Einstein.

It was not an idea, however, likely to catch the Hebrews' fancy. Their overriding concern was not the nature of God but rather his relationship with them — not with mankind in general, but with *them*. The Lord responded to this concern by laying down the law much more explicitly than before, in the carved stone tablets of the Ten Commandments. In doing so he seemed also to be changing his role in the relationship, as the Hebrews saw it, from a God of vengeance to a God of justice. Overwhelming retribution, as in the destruction of Sodom and Gomorrah, was gradually giving way to equivalent retribution, as in specifying an eye for an eye and in punishing Hebrew defiance and ingratitude with a mere forty years' delay in the Sinai desert.

This kind of change, this softening of his role as God of wrath, is indeed a feature of the Biblical record. The wrath remains throughout but is increasingly tempered by the mercy without which the fickle Hebrews probably could not have survived. Even the love behind the mercy began appearing more explicitly, more positively, not only modifying his relationship with his people but also extending into their relationships with one another. Showing mercy became a more acceptable form of worship than offering sacrifices. In the Book of Leviticus, almost hidden among the

myriad regulations on such matters as ritual, hygiene, genetics and agricultural technique, there is the famous admonition to "love your neighbor as you love yourself."

All this seems to correspond, too, to another role change, from tribal war god to solicitous father of all humanity. In the sixth and fifth centuries B.C. — that astonishing era in religious history that introduced Zoroaster, Gautama, Lao-Tzu and Confucius to the world — the Hebrews also experienced some religious upheaval. After a long and unpleasant captivity in Babylon, where many of them became intimately if unavoidably acquainted with Ahura Mazda and the supremely evil Ahriman, their conception of God seems to have changed from the source of both good and evil to the source of good contending with evil in the form of Satan. This doubtless encouraged acceptance of the notion fostered by the ever invigorating prophets, particularly by Jeremiah, of a fatherly God whose law is written in every human heart.

The Hebrews' unwelcome exposure to Zoroastrian dualism, however, in no way diminished their uncompromising monotheism. Satan, for all the angelic magnificence that accrued to him, was no more than a creature of God, who thus remained the ultimate source of evil, even if at least once removed, as Job discovered when he submitted his puzzled complaints to the Lord and was told that there were some things that he'd just never understand. The Hebrew belief in the one true God, by the fifth century B.C., had moved from its early "henotheism" (many gods, but one supreme) to strict monotheism, as though the First Commandment now read, "You shall not have strange gods — period."

In another sense of the term, the really strange god was Yahweh himself: he was unique, as the Hebrews came to recognize. He not only was One, but was The Only One. He was the only creator of the world and all it contains, the only father of mankind, the only lawgiver for all nations. He transcended the world yet actively participated in it, making generous improvements in response to petition but also abandoning it to evil consequences in response to disruptions of his moral order. In his mightiness he stood alone, mysterious and remote from human comprehension, yet in his love he could live, if invited, within each human heart.

This, in compressed summary, was the God of the Hebrews —
or of the Jews, as they also came to be known, after the loyal
kingdom of Judah. As the divine creator of the world and stern but
loving father of mankind, he would remain substantially un-
changed throughout the history of the Western world.
Philosophers would examine him and discuss him, often at stupe-
fying length, but only in efforts to explain him, or to explain him
away.

The Good Craftsman

In the fragments of Greek philosophy that have come down to us, the distinction between "God" and "the gods" is not always as clear as we might like. The terms at times seem almost interchangeable, often entirely so. This confusion—by our more meticulous standards, this carelessness—crops up in much ancient writing. Even the combatively monotheistic Jews wrote of God in a plural form in the Biblical story of creation.

The Greek sages, however, displayed no childlike faith in the indecorous clowns from Mount Olympus. Their "gods" were less clearly envisioned and were more like agents, or sometimes aspects, of a unique One. In the sixth century B.C., Xenophanes, a wandering minstrel from the town of Colophon in Ionia, ridiculed the popular belief in a plurality of gods, branding them as illusory extensions of humanity. If horses could draw, he acidly declared, they would picture their gods as horses; if oxen could draw, then as oxen. In the few fragments of his work that have survived, he described a single God greater than all the godlings and totally "unlike mortals in form and thought." Because this God is superior, he must be able to perceive and to think, but independently of any physical organs: he sees and hears and thinks in his very being. Indeed, thinking is what he *does*—his thinking "achieves everything." He is the One that explains the existence of the many.

This idea of A Mind Behind It All culminated in the "Logos," a concept and term (usually translated as "Word") that influenced Plato and Aristotle, permeated medieval theology, and lives today in a number of religious traditions. The first person to use it may

have been Epicharmus of Syracuse, who, early in the fifth century
B.C., identified it as humanity's guide on the right path of life and
as the divine source of human reason.

Half a century later Heraclitus of Ephesus wrote of the Logos
as a kind of eternal truth by which all things exist, including in-
dividual human minds. It is a unifying principle, introducing
coherence into the multiplicity and variety of the cosmos. It is also
a mind incomparable, beyond anything in human experience,
governing "night and day, in winter and summer, war and peace,
fulfillment and need." And Zeus is simply not in the same
league.

The Greek intellectuals — philosophers, poets, playwrights —
generally followed the popular usage, referring to divinity as "the
gods." They can hardly be faulted. Their plural terminology may
have been motivated partly by political discretion, especially after
Socrates had been condemned and executed for "impiety," but it
must also have had some roots in their perplexity over a timeless,
unchanging Being participating somehow in an ever-changing
world of becoming.

In the early part of the fourth century B.C., Plato (427?–347
B.C.) tried to sit astride both horns of this dilemma, uncom-
fortably and not very gracefully. His awkward position resulted
from his basic philosophy that things are transient copies but that
forms, and thereby ideas, are permanent: actual circles are im-
perfect and transitory, for instance, but perfect circularity is the
everlasting standard against which they all must be measured.
Physical circles come and go, but the form or "soul" of the circle
remains forever. By extension he conjectured that the whole world
has a permanent "soul" which permits its creator to join in its
beehive activity, much as a composer or musician joins in, and
gives special form to, the ceaseless activity that we call sound.

This analogy — Plato leaned heavily on analogy, being at least
as much a poet as a philosopher, which may largely account for
both his obscurity and his popularity — this analogy seems ap-
plicable also to the creation of the universe, which was an act not
of making something out of nothing, but rather of introducing
order into chaos. Indeed, the creator could well be called an artist,
or a craftsman, imposing form on the formless. Further, such

a craftsman must be supremely good, since order is good and disorder is evil.

The Good Craftsman could not create an absolutely perfect world, since the things that make it up can never measure up to their perfect forms. He causes no evil directly, but the imperfections make it inevitable. The problem of evil seems to have baffled Plato, the result being some undignified philosophical squirming. At one point he speculated that the world might have two "souls," one the source of good and the other of evil, but this conjecture appears in a passage that does not exactly ring with conviction.

He seems to have been convinced, however, that the Craftsman must be changeless, since divine perfection makes a change for the better impossible and a change for the worse undesirable. Yet here he was straddling the horns of the basic dilemma, that of a changeless author of chronic, unremitting change. And again he resorted to a kind of dualism, viewing God under two aspects. God as the timeless, changeless One—the God who eternally "is"—stands quite apart from the world. Nevertheless, as the ultimate active force that gives the everchanging world its form, he infuses it with the divine presence.

Furthermore, in this latter role he acts as a kind of divine providence, attending to details much as a good human craftsman lavishes attention on the details of his work, to make it as good as can be. Like the human craftsman, he may be somewhat frustrated by the limitations of his material, but his purpose is all to the good.

The Greek philosophers of course claimed no outside inspiration or guidance, no divine revelation. Yet Plato's God—the paragon, the source, and the sustainer of all that is good in the world and all that is honorable in human nature—was to give students of revealed religion plenty of food for thought.

The Ultimate Intellect

Aristotle (384–322 B.C.), although deeply indebted to his mentor Plato, flatly disagreed with the notion of transcendental forms, of heavenly templates hovering above for the guidance of the gritty realities below. The form of a thing is within it, he argued, making it the kind of thing it is.

To explain change, he offered a distinction between the actual and the potential. A seed, for instance, is an actual seed but a potential flower. In such continual change he detected order — acorns produce oaks, never petunias — and in such order he detected purpose, but he was not clear about whose purpose it might be. (The surviving record of his thought consists only of lecture notes and it is therefore easy to do him an injustice.)

He thereby detected a theme of causation in continually changing reality, rejecting the contemporary materialists' opinion that orderly progression results simply from chance. Since effects can also be causes of other effects, this progression can be observed continuing inexorably in time (which, curiously, he considered to be eternal). Yet this interminable series of caused causes is not self-explanatory; some external, uncaused cause must be responsible for sustaining it in perpetuity.

But what could be said about this first cause? Not much, as it turned out. Aristotle saw things, not uniquely, in a kind of hierarchy of reality, proceeding generally from nearly formless matter at the low end to form without matter at the high end. What he called form might today be called organization, with things rising from perhaps a shapeless goo near the lowest rung of reality, through vegetables and animals, to the thoughtful human near the highest.

On the very top rung was an immaterial, unchanging being of pure form, pure act, with no potentiality unfulfilled. This could be identified only as the first cause.

Further, as a certified intellectual, Aristotle considered human thinking to be the highest kind of observable activity, and from this he extrapolated to a being of pure thought. Since thought itself is the highest object of thinking, this being must be continuously absorbed in thinking about itself. Just how this total self-absorption could permit any causal activity remains a mystery to this day.

His conception of God is thus not of a sort likely to set popular imaginations aflame with doting affection. This Ultimate Intellect is as far removed from daily life as the most remote God of the Far East. Daily life, indeed, seems rather superfluous, since the divine thinking — completely intuitive, never changing — can have no object other than itself.

Like philosophers before and especially after him, Aristotle had a striking talent for erecting rigidly complicated logical structures on shaky foundations. His offhand assumptions and gratuitous value judgments can sometimes leave a reader gasping while desperately trying to maneuver through the intellectual jungle gym. His elusive demonstration of the proposition that time is eternal may serve as an illustration. Time, he says, is a moment preceded by a past and followed by a future. If it had a beginning, it could not at that point be preceded by a past, and if it had an end, it could not at that point be followed by a future. Since it therefore can have neither beginning nor end, it must be eternal. There is no record of how many students he left sputtering.

Despite such lapses, his powers of observation and the prodigious range and acuity of his insights generally served him well in his discussions of the physical universe and some of its metaphysical implications. Yet the God he mentions, almost incidentally, seems little more than a projection of his own contemplative genius into the realm of the infinite.

Jesus

During the three centuries between Aristotle and Jesus Christ, Hebrew notions of God were gradually shifting in emphasis from a just wrath to a loving mercy. The shift, however, seems to have been confined largely to liberal mavericks, with the conservative Establishment dedicated to a meticulously demanding God obsessed with ritualistic niceties, and apparently eager to punish any failure to observe them. In addition, the God of the liberals was increasingly the solicitous Father of all mankind, while the God of the Jewish Establishment tended to be rather disdainful of people in proportion to their distance from the province of Judea.

Early in the first century A.D. the strident voice of a rough-hewn desert ascetic named John the Baptist could be heard in the midst of this uneasy milieu, calling for greater attention to such things as honest and generous dealings with others. He was, he asserted, merely a forerunner of another, much greater prophet who would have much more to say on the subject. The person he was speaking of, of course, was Jesus Christ, who did indeed have quite a lot to say.

The God of the Establishment, Jesus maintained at the risk of life and limb, was largely a product of ecclesiastical fuss-budgets. His God was the God of the prophets, not of the priests, a God less interested in formal rules and regulations than in self-denying love, love not only for him but also for friends and even enemies. This God was not the property of a specific tribe, or city, or nation, or empire; this was the Father of all mankind who, like a human father, loved his children and desired them to love him and one another.

Unlike the God of the Greek philosophers, this was a God who revealed himself to mankind, and who was now especially revealing himself through the words and deeds of Jesus. And also, indeed, revealing himself through the very person of Jesus, who made the unprecedented and mysterious claim of somehow sharing in the divinity of God: "I and the Father are one." It was a highly controversial claim that would cost him many followers and, in the end, his life.

It would also cause many a furrowed brow for many centuries to come — and here and there throughout the rest of these pages. The followers of Jesus, notably Paul of Tarsus and John the Apostle, presented his claim as miraculously demonstrated truth (demonstrated particularly by his resurrection after being executed), although they did not pretend to understand it. In addition, they promulgated his promise that the Father would continue to provide mankind with guidance through a "Spirit of Truth" that likewise shared in the ineffable divinity. They thus gave rise to the idea of the Trinity, but without devoting much detailed attention to its implications. They were preoccupied with other, more urgent matters, including survival. The detailed attention would have to be left to later, less harassed generations.

For the early generations of Christians it was enough to present God as a loving Father who had now sent his divine yet human Son into the world with a message of forgiveness to his other, all-too-human children, who in turn were expected to show forgiveness to one another, without caviling over just desserts. Jesus spoke of his Father being "in heaven" and of the Father's will being done there, suggesting but not explaining a spiritual place or state of residence for the One whom he also described as the only true, the good and perfect God. In later centuries much was to be deduced about this God from the reports of his remarks and those of his early followers. The God of Jesus was destined to be obscured by theological embroidery and distorted by human passions. For many, in the old role of Yahweh, he would at times even revert to being a god of war again. But from within the thicket of words and the smoke of battles, he would continually and irrepressibly emerge throughout succeeding ages as the God described by John the Apostle. "God," John wrote in one of his letters, "is love."

The Provident Intellect

At about the time that Jesus was proclaiming his God of loving forgiveness in Palestine, a philosopher aptly named Philo Judaeus, a member of the Jewish community in the very Greek city of Alexandria on the Nile Delta, was struggling with the problem of reconciling the abstract God of Greek philosophy with the very vivid God of the Jewish scriptures. A devout Hebrew—he often would reject an idea on the grounds of impiety— he nonetheless felt strongly that these were really the same God revealing himself in different ways.

Philo accepted the Aristotelian God of supreme intellect eternally engaged in self-contemplation, equating this unalloyed, totally existing spirit with the "I am" of the Bible. He also found Aristotle's "first cause" compatible with the Creator described in Genesis, but he could not countenance its depressing lack of interest in its creatures. To fill the gap he offered a Platonic idea of a "Logos," or "Word," a kind of divine intellectual principle giving form to the universe and guidance to its intelligent inhabitants.

Like Einstein two thousand years later, he was very much impressed with the form of the universe, with its order and design and with the dazzling ingenuity it revealed. Such spectacular craftsmanship, he maintained, proved the existence of the supercraftsman. Yet it also placed that craftsman beyond the pale of human comprehension: using human intelligence to analyze God was something like using a candle to examine the sun. Who, with any assurance, could possibly say anything positive, who could ascribe any specific quality to the ultimate creator of all things?

The answer to this question turned out to be Philo himself.

Starting with essentially negative assertions as to what this deity could *not* be, he eventually worked himself into a state of considerable assurance as to what it could be, or indeed *must* be. It could not, for instance, be dependent in any way on anything else. It could not need anything, or lack anything, and it must therefore be unchanging, existing without beginning or end and beyond what we know as time and space. Being unchanging, it must exist absolutely, with no potentiality unfulfilled, encompassing the "pure form" of Plato and the "pure act" of Aristotle. Nor could it be physical, since all we know of physics suggests continual change.

It had to be something more than merely "it," however. To deny that it could be aware of anything outside itself, to deny that it could exercise control over its creation, to deny that it could have any discernible personality — such denials imposed limits on this limitless being, imputing deficiencies where there could be none. And so it was that Philo spoke not of "it," the cold and faceless Ultimate Intellect, but rather of "him," the Provident Intellect and Father of mankind.

This God was not immobilized in self-absorption. He did things. He changed the course of events, communicated with his creatures, and showed what could be interpreted as human emotions. If he revealed himself in anthropomorphic terms, who could reasonably deny him that option?

He was the God of Moses and the prophets, ubiquitous, all-powerful, self-sufficient, perfectly happy and happily perfect, independent of the world yet operating within it. If the idea that he could have a relationship with his universe made him incomprehensible, that was to be expected, since he was quite incomprehensible with or without such a relationship. If the Bible pictured the Unchanging One as very changeable, if not downright mercurial, is this sufficient reason for the Supreme Creator to be summarily dismissed by his dimwitted creatures? Or do such paradoxes come from the struggle of human interpreters to portray the unportrayable? Are they part of the mystery that must necessarily enter into any relationship between mankind and God?

Philo could not dispel this tension between Greek reason and

Hebrew faith; it remains a subject of thought and discussion in the twentieth century. But, by facing the issue and treating it dispassionately, he offered a concept of a God of reason and faith that a human intellect could adopt without acute discomfort. His offer was to be accepted more widely than he could ever have dreamed.

The Unknown God

While Philo was announcing his message of accommodation to the Gentiles during a relatively easy life amid the cosmopolitan comforts of Alexandria, history's most famous traveling salesman was tirelessly carrying a similar but more invigorating message back and forth among the communities scattered along the shores of the eastern Mediterranean. The message was the good news of Jesus Christ's reconciliation of all mankind with God, Gentiles included, and the salesman was the opinionated, nettlesome, erratic, egocentric, severe, picayunish, puzzling, learned, eloquent, affectionate, mystical, and totally dedicated Paul of Tarsus (1st century A.D.).

His influence on the course of Christianity was incalculable. A case can be made, and often has been made (by Nietzsche, for instance, in vituperative spades), that he was more trouble than he was worth. He has been charged with distorting Christianity into an institutional nightmare but has also been credited with saving it from oblivion. He provoked intense controversy throughout his life—first as a Pharisee fiercely hunting for Christians, then as a Christian fiercely hunting for converts—and has continued to do so for the past nineteen hundred years. Controversy seems to have come with the territory.

That territory included Athens, where Paul did a good deal of preaching. Among other things, he slyly complimented his audiences there on their piety, exclaiming over the many fine temples in the city. He had noticed, he said, even an altar dedicated "To an Unknown God," and now he had arrived to make that God known. This is a God not confined within any temple, he

41

explained; this is the Creator and Master of heaven and earth, the source of all life who will live within us if we will just give him a chance.

This approach, especially when he associated it with the idea of a man risen from the dead, seems to have drawn a mixed reaction. The deity gap was formidable. Despite his Roman citizenship and Greek orientation, Paul was steeped in the Old Testament, and his God is essentially the biblical Father, the wrathful scourge of sinners and forgiving savior of the repentant. He is still the God who transmits his law to the Jews through Scripture, including the words of the prophets. Yet he also is the God who has written the law in Gentile consciences, who offers a new contract of love and salvation to all people, rather than to only a chosen people, a contract guaranteed by the sacrifice of his Son and now advertised by the Holy Spirit through the Son's apostles, including Paul himself. This is a God incomprehensible but by no means remote. He is accessible through prayer. Indeed, those who accept him (through baptism) and live up to their contract with him (through their faith) are not merely members of his church but also members of the mystical body of the risen and glorified Christ.

Thus the resurrection of Christ is logically as well as mystically indispensable to the Christian faith, which is, Paul insisted, meaningless without it. The resurrection, together with the life and death that preceded it, is part of the divine providence, part of God's plan for rescuing those who love him from the fatal allurements of Satan and the world. Such allurements will prove powerless if we love one another. Love alone is the key to everlasting happiness, here and hereafter.

But Paul advised all who would listen not to be laggard about getting on God's bandwagon. His letters sound a note of urgency unmatched elsewhere in the New Testament. Unlike Jesus, he seems to have been convinced that mankind wasn't long for this world. There was little time left, he warned, for "the day of the Lord is at hand." This anxiety, which seems to have colored just about everything that he said and wrote, must be taken into account in reading his gruff opinions on the minutiae of rite and wrong. But his picture of God does not seem to have been

much affected. It is, after all, a picture familiar to uncounted millions throughout the Western world and down through the ages, including Abraham, Jesus, Luther, and Pope John Paul II.

The Governing Mind

Before his conversion Paul had busily persecuted Christians presumably because of the religious threat they presented. A hundred years after his death, however, partly due to his later impassioned proselytizing, the Christian community had grown widespread and populous enough to represent a political threat to the Roman imperial establishment, which, though disdainfully tolerant of religious diversity, took quite a deadly view of civil unruliness. For the next couple of centuries Christians were persecuted by various Roman emperors with various degrees of enthusiasm and with various degrees of failure.

An unenthusiastic but relatively effective persecutor was the emperor Marcus Aurelius (121–180). Persecuting Christians and other subversives was part of his job, as was waging war. He found both responsibilities highly distasteful, but he was conscientious to a fault. A job is a job is a job.

Some clue to his character may be seen in the fact that he wrote his famous *Meditations* on the fringes of the empire, where he was leading his legions in forays against the barbarians. Doubtless we can be confident that he scrupulously wrote it only on his own time, but it is a significant way for a military commander to spend his harried leisure hours. He apparently had a gift for equanimity in the midst of turmoil, and probably for concentration in the midst of distraction. For he was, after all, perhaps the most dedicated and articulate of the Stoics.

The Stoics' portrait of God shared a few essential features with the Judaeo-Christian portrait. In Athens, Paul, in describing mankind as God's children, was able to cite the Greek Stoic

Cleanthese to that effect. For Marcus Aurelius, the orderly universe that he observed necessarily implied a superlative mind governing its operation. He conceded that this universal Mind is invisible, if only for the sake of argument. (He may have imagined that "the gods" were spectacularly visible in the sky above.) He was quite comfortable with this invisible Mind since he was convinced that his own mind, though similarly invisible, was nonetheless real—like everyone else's. His comfort was limited only by his awe at the power of this all-governing Mind, making it worthy of the most circumspect veneration.

The Mind thus posited is everywhere, infusing human bodies with the rational intelligence that distinguishes mankind from other animals. That rational intelligence, in fact, *is* the human being, for whom the body is merely a form of clothing. The Mind is like the air that surrounds us, enters into us, and animates and sustains us. Our duty is to accept this living, energizing intelligence, to make it part of us, so that we can approach some degree of unity with it. And, further—and here we can see a source of Stoic resignation—to accept its government of the world, particularly of those aspects that we can't do anything about.

Accepting the order of the universe, as is, means also accepting the disorder in it too, or at least what seems to us to be disorder. Since Marcus did not have time for speculating about such imponderables as absoluteness and infinity, or about unnerving contradictions between unlimited goodness and widespread evil (the *Meditations* have some of the preceptive flavor of *Poor Richard's Almanac*, or Mao Tse-tung's little red manual), he simply accepted disorder, or evil, as a fact of life about which, by and large, nothing can be done. What we call evil, he maintained, is more the exception than the rule, especially when we consider the benefits arising from it—the living plant arising from the seed that died, the new person emerging from the pain of childbirth, and so on. As for the evil that other human beings may do, we must conduct ourselves so that the evil is in them, not in us. Beyond this he did not care to go. He considered the ways of the governing Mind to be too mysterious, too far beyond human comprehension, for him to justify them to everyone's satisfaction.

The Graduated God

In its second and third centuries Christianity was prey not only to the slings and arrows of outraged Romans but also to the competitive vivisections of quarrelsome intellectuals. Among the enigmas left behind by Jesus, and more especially by Paul, was the idea of the Trinity. By the middle of the second century the God described in the Apostles' Creed (Almighty Father, Christ the Son, and Holy Spirit) seems to have gained widespread acceptance in the Christian communities ringing the Mediterranean, but the description is so spare, so noncommittal, that it created at least as many problems as it may have solved, problems begotten and sustained by the perennial, epidemic human urge to use religion in the greater cause of bickering. Jesus himself had said, wearily, that he was bringing not peace, but the sword.

Historians of the period, frustrated by documentary gaps and the deafening theological noise, lumped together at least some of the teeming variety of apodictic opinions under the general heading of Gnosticism. Some Gnostics insisted that knowledge of the truth (*gnosis*) is the only road to salvation, which has nothing to do with faith or good works. (This naturally led to a proliferation of subcults with absolute monopolies on the truth.) Others stressed that all material things are repellently evil, including the grossly physical human body, and therefore withdrew into a disengaging asceticism. Still others rejected the Hebraic God of Righteousness for an Hellenic God of Wisdom. None seems to have favored any idea of a Trinity, and eventually Gnosticism disappeared into the maw of Manichaeism, fatally attracted to that sect's two eyeball-to-eyeball Zoroastrian gods of good and evil.

Meanwhile a sect spreading out from Phrygia in Asia Minor invited a good deal of feverish attention, both pro and con, with its wholehearted acceptance of the Trinity, or at least of its own version. Montanism stressed the imminent Second Coming of the Second Person, about whose plans it had private information obtained through its exclusive hookup with the Third Person, the Holy Spirit. Many Montanists, indeed, strongly suspected that their leader Montanus comprised Father, Son, and Holy Spirit, since he said so. It was to this yeasty sect that the combative Tertullian of Carthage (160?-230?), a transient "father" of the early church whose incisive mind earned him at least a major footnote in the annals of apologetics, eventually decamped.

The views of Tertullian and of the more orthodox Clement of Alexandria (150-220?) seem to have exerted a formative influence on a much younger man later described by St. Jerome (in a burst of fine careless rapture, subsequently repudiated) as the greatest of Christian teachers after the apostles. This was Origen (185?-254?), a tireless defender of the faith who nevertheless held some maverick opinions that eventually brought him a glowing condemnation by the emperor Justinian I and some other church-state poohbahs. On the subject of the Trinity he fell somewhere between (though anticipating them by a century or more) the heretic Arius (d. 336), who stoutly asserted that the Father is divine but the Son merely human, and the orthodox saints Athanasius (293?-373) and Basil (330?-379?), who as stoutly replied that both Father and Son are divine. Such intellectual stoutness was more characteristic of the age than, say, circumspection.

Origen's philosophy hinged on his belief in divine goodness and in human freedom to emulate that goodness (or disdain it). As a human soul grows in knowledge and sanctity, it will see God in increasingly truthful stages. Thus the pagan barbarian's God is a humanoid amalgam of the human tragicomedy, the God of the Old Testament is a single transcendent spirit but exhibits some embarrassingly human hostilities, and the God of the New Testament is quintessential love. Somewhat correspondingly, the true God is a graduated God, existing on more than a single level.

The God whom we call Father is the supreme, infinite origin of all existence, the all-powerfully good, eternal First Person

Singular. Through his loving Word, the Second Person, he created rational souls in his own image, in an act of self-restriction. He is both above and within the world, independent of it yet somehow needing it as a focus of his necessary activity, which keeps it in existence. In his relationship with his rational creatures, angelic and human, he is persuasive, not coercive. They are free to reject his love, and indeed they did so, in a general fall from grace.

But one soul, so infused with his love that rejecting it would have amounted to self-rejection, did not participate in the fall. This soul, God's Word made flesh through the Virgin Mary, the Second Person sharing in the First's divinity, became the channel of opportunity for the fallen souls to restore themselves, through love, to divine favor. The Father is single but the Son is multiple, existing on many levels or gradations, through which each human soul can pass on its way up the ladder to perfection. As the Father is united with the Son, so must the Son be united with the faithful, in the final triumph over moral evil.

Physical evil, in God's plan, is an antidote to moral evil. General evils like famine and pestilence and other natural disasters are a reminder to mankind that this world is not the paradise for which it is intended. More particular evils, from the scourges of the Old Testament to the individual ills that flesh is heir to, are not punitive or capricious but are meant to be remedial. What Job needed to cure his perplexity, it seems, was an Origen.

Origen's portrait of a graduated God was criticized for demeaning the Second Person to a role of inferior status and thus promoting heretical "subordinationism." In 225, when he was about forty, the first Nicene Council had promulgated its famous creed emphasizing the Son's "being of one substance with the Father," and the orthodox establishment was uneasily sensitive to any deviations on the subject. Whether some of Origen's views were unmistakably heretical — evidently his intentions were not — may have been too fine a point to insist on during these times of passionate opinion-mongering.

The Radiant One

About a hundred years later, in Alexandria, a Greek-speaking and Greek-thinking philosopher named Plotinus (205?–270?) offered a package of opinions that eventually earned him a niche in history as "the father of Neoplatonism." Although he freely picked the brains of many of his predecessors, his major reliance on Plato is unmistakable.

He liked Plato's idea of God as the Good Craftsman, and he also was attracted to Aristotle's unchanging, self-contemplating Intellect. Yet the two seemed incompatible. How could unchanging Intellect be the source of the ever-changing multiplicity of the universe? Every single thing in the world, he had observed, has a unity that makes it what it is—dismember it, and it ceases to be what it was. This led him to believe that God, as the ultimate identity, must be purely One, the absolute and indivisible Unity. But how could such Unity produce anything else without experiencing some change, some lessening, in itself? To answer this question he resorted, like his idol Plato, to analogy.

The Supreme First Cause, he suggested, is like the sun, which produces its effects by radiation while experiencing no change in itself. It is like an inexhaustible spring, providing water without any change in the supply. It is like a flower, giving off its fragrance without any lessening of its beauty and vitality. His explanation was ingenious, even though he would doubtless be shocked to learn, today, that the examples he chose are teeming with countless changes every microsecond, inexorably diminishing.

This information from modern scientific instruments, however, probably wouldn't have shaken his belief in the One as

the source of all good things in the world. As for the problem of evil also existing in the world, he considered evil as a negation, as a deficiency of the good, much as cold is a deficiency of warmth. Since only the One could be perfect, anything existing outside the One would have to be imperfect. The amount of imperfection was simply a matter of degree.

Like Plato and Philo, he held to the mystical idea of a divine Mind emanating from the One, and a universal Soul emanating from the Mind. The Mind somehow contained all forms, including individual human souls, the most noble elements in human nature, while the World Soul, as a further intermediary, energized the world of matter at the lowest level of reality. Plotinus generally looked down his nose at matter — including the human body — with a mild disdain that would help to color much of the thought of the succeeding centuries.

The body was chiefly something to escape from, as often and as completely as possible. Plotinus himself, according to his friend and editor Porphyry (232?–304?), made his own occasional escapes by means of mystical trances in which his soul ascended through the World Soul and the Mind to the One. In this spiritual union with the One, all the world is left behind, all its troubles and anxieties, all its petty pleasures and desires. The soul loses itself in serene contemplation of the transcendent source of all beauty and all good. Imagine, after such an experience, how distressing the return trip must have been. (There is no record of his having any pharmaceutical assistance, before or after.)

The God of Plotinus, although perhaps accessible to the gifted few, seemed quite beyond the reach of lesser mortals. The divine love was inner-directed rather than outer-directed, passive rather than active. The Source of the world showed little interest in it and its inhabitants. As Plotinus himself suggested, this was a lonely God, sought by lonely souls.

For ordinary folk, this was a deficient God. In the Far East, such deficiency was widely compensated for by the solicitude of countless godlings. In the West, such godlings were fading fast as pagans grew ever more worldly and Christians grew ever more numerous and vocal. With the rise of Christianity, the deficiency would have to be compensated for in some other way.

The Provident Trinity

About a hundred years after the death of Plotinus, a brilliant young teacher of rhetoric in northern Africa was becoming fatefully embroiled in the effervescent religious controversies of the time. He spent his early and rather profligate years, in the late fourth century, as a follower of Manichaeism, a colorful and vaguely Christianized form of Zoroastrianism complete with dual deities of good and evil. Its occult extravagance appealed to the mystic in him, yet it offered so many unanswerable questions and questionable answers that within a few years he deserted it for the less perplexing, if still unsatisfying, tenets of scepticism.

Scepticism offers any mystic an uneasy harbor at best. On a trip to Italy, Augustine (354–430) found a brief refuge in the Neoplatonism of Plotinus. In Milan he met the scholarly and eloquent Ambrose (340?–397), bishop of that city, and in 386 was formally converted to Christianity. Only ten years later he was consecrated bishop of Hippo in northern Africa, thus becoming a full-fledged member of the Christian Establishment.

In 313 the Roman Emperor Constantine had declared Christianity to be officially tolerable, and by the turn of the century it had replaced paganism as the religion of the Empire. To this end it had become more formally institutionalized, with a governing hierarchy and a growing collection of stipulated beliefs. It was now, in short, the Catholic Church, and Augustine was to become one of its most celebrated spokesmen. By this time the most generally accepted Catholic idea of God was essentially what it is today. Indeed, Augustine presents it in terms very familiar to just about any Christian of the twentieth century.

He felt no need to forsake Neoplatonism entirely. He found its combination of One, Mind and Soul quite compatible with the Christian Trinity of Father, Son and Holy Spirit — three "Persons" sharing the same eternal Substance in mystical personifications of the divine existence, intelligence and will. This God was, he quite readily conceded, an enigma — but was also, he declared, a living, all-knowing, all-powerful Providence, actively nurturing and sustaining all creation.

That creation, unlike the universe of the Greek philosophers, was by no means eternal, having been formed out of nothing by its Creator. Although formless matter may constitute a kind of eternal potentiality, the changing universe that we observe is intelligible only as a finite thing (otherwise, the ever-increasing number of actual changes must be uncomfortably considered to be already infinite). This involved the idea of time, which Augustine treated much more humbly and gingerly than Aristotle, confessing it to be a puzzle and finally concluding that it probably represents a psychological, rather than a physical, reality. In reply to critics who slyly asked what God was doing before the moment of creation, he stoutly asserted that the very word "before" was meaningless in this context, since time could not exist without creation. Thus the notion of time was quite irrelevant in any consideration of God. Doubtless he remembered the statement attributed to Jesus Christ, "Before Abraham was made, I am."

He held on to Plato's eternal, ideal forms, however, as residing in the divine Intelligence and giving every created thing its intelligible identity. These forms are indirectly intelligible to ordinary reason, which can catch a hazy glimpse of them by extracting common characteristics of individual members of a group. But, Augustine added with perhaps a touch of self-satisfaction, they are *directly* intelligible in the less ordinary insights granted to the gifted mystic. His own mystical experiences were by no means infrequent and included a celebrated one that led to his conversion.

Yet he made no extravagant claims for his mystical insights. On the contrary, his writing reveals a man beset by uncertainties like the rest of us, often praying desperately to his Lord for understanding. He thought of God as Truth, but as Truth

accessible to mankind only through the revelations of Scripture as interpreted by divinely assisted human reason. He agonized over the paradoxes in the relationship between Infinite Creator and finite creatures while holding firmly that such a relationship does exist. However imperfect the creatures, he insisted, God is somehow present in every one.

Imperfection implies evil. He agreed with Plotinus that the One is the source of evil only in the sense that evil is the absence of good. He went further, however, distinguishing between physical and moral evil, ascribing the latter to the operation of human free will. Yet his position is not entirely clear, since he also thought that God's saving grace could be so overwhelming as to be irresistible. His thinking here clearly was influenced by his own experience, since he felt that he had been saved from a hopeless degeneracy almost against his will. He has even been interpreted as subscribing to the doctrine of predestination.

The ideas of free will and saving grace are not totally incompatible, but they produce enough tension to have posed some irritating problems for others besides (and especially after) Augustine, especially in connection with God's "foreknowledge." But then paradoxical ideas about God, whether humanly generated or divinely revealed, have caused many problems and will surely continue to do so for as long as God is an object of human thought. In a passage early in his famous *Confessions* Augustine addressed God as unchangeable yet responsible for change, embracing everything yet needing nothing, always in search yet always in possession, just yet compassionate, angry yet serene, jealous yet carefree, regretful yet joyful—and so on. Some of his contemporaries and successors would find such paradoxes too contradictory for acceptance; he could tolerate them, some would say, only because he emphasized intuition at the expense of reason.

Their resistance is entirely understandable. Yet one can wonder how they might have felt, today, about the general theory of relativity, with its notions of space curving in on itself and of flexible time stretching with increased velocity. Have we any reason to believe that God must be less paradoxical than his universe?

Allah

Some two thousand rugged miles east of Augustine's city of Hippo, the barren Arabian peninsula was populated at the time by a myriad of largely nomadic and very contentious Semitic tribes ardently engaged in reciprocal blood-letting. A profusion of tribal gods, or "ilahs," provided the necessary religious fervor in this turbulence, but by the close of the sixth century they had lost much of their influence to *the* god, "*Al*-ilah," headquartered in the bustling trade center, Mecca, on the coast of the Red Sea.

As a trade center, Mecca was the peninsula's chief point of contact with foreign ideas, including ideas about God from Jews, Christians, Zoroastrians and Greeks. The idea of repentance for idolatry particularly appealed to a Meccan religious group called Hanifs, an association of ascetics who, scorning tribal ilahs as so many irresponsible tooth fairies, proposed a life of "islam," submission of the human will to the one God, Al-ilah, or Allah. Mankind, they maintained, must return to the ancient religion of the patriarch Abraham.

Their ideas might have disappeared in the current of history but for the emergence of a remarkable man, an illiterate but strong-minded Meccan who had spent his early life herding sheep, driving camels, and leading caravans. After marrying the owner of a caravan operation, a wealthy widow, he became acquainted with the Hanifs through her family. Their ideas touched him to the soul. Thereafter neither Mohammed (570–632) nor the Hanifs would ever be the same.

Fortified by periods of fasting and contemplation, inspired by the archangel Gabriel in a vision, and encouraged by his loyal

wife, he began preaching the faith of Islam. In 622, after the death of his wife and an affluent uncle had deprived him of their protection and support, he and some of his followers fled from a hostile Mecca north to a friendlier town, Medina. There he was so successful at separating warring factions from one another's jugulars that he was able to return to Mecca in 630, conquering it and becoming ruler of all Arabia. During the century after his death in 632, the Islam faith was spread, by dint of word and spur of sword, throughout northern Africa and the Middle East and even into Spain and southern France, where it was finally halted and turned back by Frankish forces under Charles Martel.

Thus Allah proved himself a mightier God of Battles than Yahweh had ever been. During this century of expansion he was a stern and quite forbidding God, especially to infidels rash enough to resist the new imperialism. Afterward, when some semblance of peace had been achieved, the softer aspects of his nature, as revealed in the Islamic sacred scripture, the Koran, received a greater share of attention. Allah is a very personal Creator with ninety-nine other names describing him as, among other things, both the wrathful Destroyer and Avenger and the mild, forgiving, loving Protector and Provider. Like other successful versions of God, he is versatile enough to meet the demands of different times, places, and people.

Above all, he is the One, the only One. The Arabs' long experience with a teeming polytheism evidently left them quite ready to stress the absolute singleness and singularity of God. As Moslems, they refuse to countenance any other deities and flatly deny the possibility of the Christians' Trinity. As the historic God of Abraham, Allah is not to be replicated in any sense, however restricted or mystical. He is already all things to all the faithful, and that is enough.

To emphasize this, he is not called "Father." The early, pre-Mohammedan Allah's rise to divine primacy had resulted in demoting certain Meccan godlings to the status of his children, but Mohammed would have none of this. Allah, being unique, can have no divine offspring, even in an analogous and mystical relationship. He has a retinue of angels to act as messengers, to intercede for forgiveness of human sin, and to perform other

services. There is even an equivalent of the Christian Satan, the proud Iblis, industriously sowing evil in the world. But these are mere creatures. Only Allah is divine.

So absolute a God, all-knowing and all-powerful, is likely to be considered all-controlling as well, and parts of the Koran do indeed present Allah as the inexorable determiner of every move by everyone and everything in the world. This notion of inescapable "Kismet" was the view of a noted twelfth-century spokesman for orthodox Moslem theology, the mystic Al-Ghazzali, and it has been especially appealing to absolute rulers in the Moslem community. Other parts of the Koran, however, dealing with human responsibility, have given rise to other interpretations. Thus another noted Moslem sage of the twelfth century, the Spanish Averroes, seemed inclined to an almost Christian concept of free will, and an Egyptian reformer of the nineteenth century, Sheik Muhammed Abdou, summarily dismissed the fatalistic view of divine omnipotence.

Every scripture has invited divergent viewpoints. The Allah of the Koran is a paradoxical God — eternally unchanging yet active in what we know as time; spiritual yet corporeal; remotely above the world yet infusing everything in it, especially the human heart; unbound by justice yet devoted to it, particularly for the poor; forbiddingly wrathful yet compassionately merciful. He is a jealous God, demanding strict adherence to the laws of ritual and good conduct revealed by his prophets, from Abraham and Moses to Jesus, and uniquely through the last and greatest of the prophets, Mohammed, whose word is final. By the same token he is the scourge of infidels, but to the truly faithful he is a benevolent provider.

The very nature of Islam, ideally requiring total submission of both intellect and will, tends to discourage theological speculation. By Christian standards, with notable exceptions like the works of Avicenna and Averroes, there seems to have been rather little. But this may be merely a Western impression due to language barriers and simple human prejudice. Surely Allah, as the God of half a billion people, is eminently worthy of thoughtful contemplation.

The Universal Self

A couple of thousand miles east of Mohammed and a couple of centuries later, a less combative but no less thoughtful religious leader offered a more subdued, subtler, and even more intimate portrait of the Deity, but on a broader canvas. The influence of the Hindu theologian Sankara, although his life has become so enshrouded in legend that we cannot be sure whether he graced the eighth century or the ninth, can be seen in Indian word-portraits of Brahman to this day.

Brahman, he taught, is all-powerful, all-knowing, the eternally pure, wise, and free Self of every person. He is the only God, pervading everything, utterly spiritual, entirely good. His knowledge is direct, immediate, and all-embracing, while his intelligence is as bright and enduring as the light of the sun. In his light we can glimpse him, at first as a finite being somewhat like ourselves (because our poor vision is conditioned by the limitations and the multiplicity of the things all about us), but eventually, as the light of our own intelligence cooperates with his, as the infinite, universal Self amid the illusions of physical things and of our own identities.

This progression of knowledge is a progression of the individual soul toward Brahman, whose inmost substance is eternal, boundless knowing. The soul may imagine at first that it can discern Brahman among the things of this world, somewhat as one may mistake a post for a human figure in the dusk, but when it has freed itself from the captivity of the senses, it will recognize its own total immersion in, its identification with the Self. This commingling of the finite with the infinite is the only genuine contact that

we have with Reality. Everything else is illusory, like water that
appears to shimmer on the surface of a desert. "For the Self, though
known by various names, is One alone."

Thus there is really no such thing as variety, or change, or
movement, or particularity — or pain. Pain is like the trembling of
the sun's image in a cup of water. It can be sensed by the in-
dividual, but it doesn't affect the sun in the least. If we turn our
attention from the cup of water to the sun itself, the trembling will
cease. Likewise, as we become absorbed in Brahman, we shall feel
no pain. In the last analysis, pain is as unreal as we are.

The Highest Self

The sacred scriptures of the East, like those of the West, have proved susceptible to a staggering variety of interpretations. Sankara at one point commented on the diverse ideas about Brahman floating around in his time. The Self, he wrote, was identified by different groups as the body plus intelligence, as simply an idea, as a transmigrating soul, as a void, and so on to the limits of endurance. But he and others knew that the Self comprises the sum of individual souls and the rest of the universe, whose separate existence is merely apparent.

Some two hundred years or more after Sankara, in the eleventh century, an important religious leader arose to take sharp issue with Sankara's relegation of humanity (etc.) to the realm of fantasy. Consciousness, divine or human, argued Ramanuja (fl. 1100), must have objects outside itself. Further, since the world manifests the glory of Brahman, he is demeaned by a denial of the world's reality. Finally, such a denial brands as useless all prayer and supplication, and Ramanuja was a fervent and enormously successful promoter of religious rites and popular devotions. So he proposed that the world of matter and spirit is a real world, but intimately related to Brahman, much as the human body is related to the human spirit. Brahman is not the Universal Self, but the Highest Self.

This Brahman is gratifyingly more active and personable than Sankara's anesthetic generalization. The scriptures tell us, Ramanuja declared (in an unusually argumentative style, incidentally, worthy of the more quarrelsome West), that essentially Brahman is free from defects of any kind, includes all positive,

worthwhile attributes, and is happily engaged in generating the universe, in maintaining, permeating, and reigning over it; that the world of souls and material things constitute the body of the Highest Self; that the individual souls manifesting the power of this supreme Self really exist, as separate substances and disembodied spirits; and that Brahman therefore must somehow include the universal plurality. The universe, indeed, derives its very being from its participation in the Highest Self. And Brahman has the unique distinction of being both cause and effect, generating and being generated.

This soul-and-body relationship is intelligible, Ramanuja rather artfully explained, from our observation of the human soul's support and control of the body for achieving its ends. Likewise the universe, which is divinely supported and controlled, makes up "the body of the Supreme Person." This is not a permanent, unchanging arrangement, however. Apparently it is cyclical, with the universe being reabsorbed into Brahman, losing its diversity and fading into a featureless, elemental form of matter (called "Darkness" in the scriptures), and then being shifted into reverse and reconstituted.

This process and all it involves—Ramanuja called it Brahman's "pastime"—necessitates a degree of imperfection, of evil, of suffering. But just as the human soul remains unaffected by the body's defects and aches and pains, so does the Highest Self remain untouched by the tribulations of this world. We must also remember that an ill wind for one self will often blow good for another, while the Highest Self remains in a state of total calm. Similarly, Brahman remains essentially uncontaminated by moral evil, springing as it does from the will of the individual soul. If a crime is committed, the divine soul is no more sullied by it than the soul of the victim or an innocent bystander. This is possible because Brahman, although not limited in time or space, is limited in substance, in the sense that other substances do exist.

The actual existence of other substances, other persons, seems to be the key to Ramanuja's portrait of God. Only on this premise could he argue that prayer can be worth the effort and that Brahman can be responsive to someone besides himself.

The Greatest Conceivable

Meanwhile in Europe Christian theology continued its flirta-
tion with the Platonic idealism to which Augustine had given such
weight and impetus. This flirtation, soon to be replaced by
another, saw its culmination in a celebrated "ontological argument
for the existence of God" proposed by an Italian-born (in 1033)
churchman named Anselm, who was otherwise kept busy resisting
royal encroachments on church prerogatives as Archbishop of
Canterbury from 1093 until his death in 1109.

We can conceive of a being, Anselm argues, which is the
greatest possible being, with nothing greater. Since a being ex-
isting in the mind *and* in reality is greater than a being that exists
only in the mind, this greatest possible being must exist in reality
as well as in the mind. To conceive of it as not so existing would
be a logical impossibility, a self-contradiction. Therefore the in-
finite God of whom we conceive must really exist.

He did not equate "conceive of" with "understand." He readily
conceded the inability of any human intellect to grasp the nature
of an infinite God but maintained that no such understanding was
needed within the limits of his argument. We can extrapolate from
our experience with the rising order of beings — mineral-vegetable-
animal-human, for instance — to an awareness of the greatest
possible being, without knowing all there is to know about that be-
ing. Indeed, that kind of knowledge is beyond us even with the
help of divine revelation. A thimble can hold a bit of seawater but
cannot contain the ocean.

A being that must exist of its nature can have no beginning or
end, and it must be the greatest conceivable in every respect (since

it cannot be inferior to anything else in any respect). God is not merely good but in every case must be the highest conceivable good. This proposition, Anselm discovered, brought up a disconcerting question: how could good but incompatible qualities reside fully in one God?

As an example, he conceded that God must be both dispassionate and compassionate. Reason indicates that, as the unchanging Infinity, he must be dispassionate, impervious to the tides and currents of emotion; revelation indicates, not unreasonably, that as infinite Love he must be compassionate, able to sympathize with the sufferings and emotions of his creatures. Anselm tiptoed delicately through this difficulty by distinguishing between the divine and the human experiences. God perceives our misery, he suggested, and we interpret his perception as compassion — and this lessens our misery. That is our experience, but not God's. He remains dispassionate, unmoved by any aspect of the event. A possible analogy might be that of a preoccupied mother singing her child to sleep without feeling any particular affection for it at the moment. No analogy can adequately describe any aspect of God, of course, but then neither can any other mental operation. Nor can words like "dispassionate" and "compassionate." We simply use such tools as we have.

Anselm's God is limitless, transcending his creation yet infusing it with his presence, supremely indifferent yet intimately involved, loving Self and creatures in a mystical, incomprehensible interaction. Although far beyond the reach of our minds, he lives within our hearts.

The Three-Ply Enigma

As our glance at the opinions of Anselm may have suggested, Augustine's Platonic authority dominated Christian theological thinking for half a dozen centuries after his death. His view of the Trinity thus received general support in this authority-ridden age, but eventually it proved too fuzzy for the theological lint-pluckers, and by the eleventh century the noise of plucking was reverberating throughout the lint-filled air.

The shrill commotion was chiefly over the Holy Spirit, who surely had done nothing to warrant this rabid and unruly scrutiny. The most feverish controversies, however, centered not on what he might have done but rather on where he came from. In the eastern Mediterranean and environs, those who knew about such things insisted that he came, or eternally comes, from God the Father through the Son. In the western Mediterranean and environs, those who knew about such things with equal certitude insisted that he came, or comes, from both Father and Son together. Although today it may seem quite unbelievable to tolerant and ecumenical us, this was the argument which, in combination with differences over political power and papal supremacy, split medieval Christendom into two bitterly rival camps in the "Great Schism" of 1054. A century and a half later, during the fourth Crusade, some pious western Catholics tried to persuade the eastern Catholics to see things God's way by attacking and sacking part of Constantinople, but this apparently was not the kind of cement needed for patching up the badly divided church. The division endures to this day.

Within each camp religious thinkers generally tried to keep

cool in order to keep from getting burnt, figuratively or literally. Often, however, the compulsion to reveal the Truth overwhelmed the instinct for self-preservation, and the anathema business thrived almost as briskly as the indulgence business. Amid the uproar in the west one of the clarion voices belonged to Peter Abélard (1079–1142), whose fame as a controversialist at the time exceeded (but did not outlast) his reputation as a paramour, or ex-paramour. His life was filled with condemnations, book burnings, house arrests, assassination attempts and other approaches to theological polemics. His death was much more peaceful; he even was reconciled with Bernard of Clairvaux (1091–1153) his obsessively orthodox lifelong pursuer (and later saint).

For Abélard, God was the familiar amalgam of Jewish and Greek monotheism — unique, unlimited, unequaled, indivisible, all-powerful, all-wise, all-good, a spirit perfect in every respect, and so on. And he wholeheartedly accepted the Christian doctrine of the Trinity. As something of a philologist, however, he was very suspicious of words as conveyors of abstract thought, as well as of analogy as a method of learning the unknown by means of the known. He found this frustratingly true of the effort to understand the nature of God, for "the more the divine nature excels the other natures it has created, the harder it is to discover satisfactory analogies in those other natures."

He had serious doubts, for instance, about the way the word "substance" was bandied about in discussions of the Trinity. We are fairly well acquainted with the meaning of "substance" in the physical world, because that is what "accidents" adhere to, but how can the word be used meaningfully about God, who is pure essence, totally dissociated from accidents? He felt the same way about the use of "persons" in descriptions of the "hypostatic" union in the three-in-one God. We ordinarily think of a person as a rational individual. How can we speak of God as rational, reasoning from the known to the unknown? How can we speak of him as an individual, distinct from us in the same way as we are distinct from one another?

Like other philosophers, Abélard was better at asking such questions than answering them. His own efforts to fathom the Trinity were — well, his best-known analogy used the concept of

the copper seal then commonly employed by officials to impress wax in sealing documents. The copper is the material the seal is made of, the official's image gives the copper its form, and the act of sealing comes, not from the copper alone or the image alone, but from both together. (He neglected to add that another way of looking at it is that the sealing comes from the copper through the image.) The analogy brought instant charges of heresy, with Saint Bernard particularly agitated. But how Abélard could have been charged with *anything* on the basis of so vaporous a suggestion is hard to understand in any context other than his own, or perhaps even in his own.

Over the intervening centuries the Christian notion of the Trinity seems to have settled down into the general proposition that the Father creates, the Son saves, and the Holy Spirit sanctifies. But the question stubbornly remains, does anyone really know? Perhaps even Abélard and all his contemporaries, on sober ninety-second thought, might have answered in the negative.

The Unrelated Father

During the century after Saint Anselm's death (in 1109), the Platonic notion of absolute ideas and infused knowledge began to give way to the Aristotelian notion of general ideas extracted, from particular but similar things, by observation and reason. Perhaps the foremost contributor to this process was a Jewish rabbi, physician and scholar named Maimonides. Born in Moslem Spain in 1135, he died in Cairo in 1204 after spending his entire life in Arab lands. His debt to Arab philosophers like Averroes need hardly be explained.

He shared Philo's interest in reconciling Greek and Hebrew opinions about God and mankind. What, for example, could be said of the relationship of the unique and infinite God, who must be totally unlike any other being, with the other beings that make up the universe? Maimonides' answer was simply that God is unrelated to them. The various relationships that we think we see come not from differences within God but from differences among creatures. To illustrate, he offered an analogy from the action of fire, which has different effects on different things—softening some, for example, but hardening others—while it remains the same. Likewise God remains the same, unaffected by the continual changes of which he is the sole First Cause.

And so it is with the attributes ascribed to God by the Old Testament prophets and others. Attributes of an individual suggest a relationship between that individual and some larger, or at least other, reality, as when a man called just is thereby associated with justice in general. But since God cannot be thus related to any other reality, the attributes assigned to him can be only metaphori-

cal projections of human virtues. In relating mankind to God, we think we are relating God to mankind. But there is really no comparison. A human being may or may not exist, have power, be wise, and so on. But God *is* eternal existence, power, wisdom — and everything else — quite untouched by all those things we say about him.

Thus, Maimonides continues, the only reliable conclusions that we can reasonably come to about God concern what he is not rather than what he is. When we say that he exists, we are really saying that his non-existence is an impossibility. When we say that he is pure act, we are really saying that he can have no unfulfilled potential. When we say that he is spiritual, we are really saying that he is not merely physical. When we say that he is all-knowing, we are really saying that he is not ignorant of anything. Negative attributes — such as are expressed by such unimaginative terms as in-finite, un-changing, time-less, im-material — are concepts we can handle; positive attributes, however vivid our imaginations, are actually quite beyond our ken. It is always easier to say what a thing is not than to say what it is, and this is especially true of God. Whenever we think or say anything positive about God, we are indulging in very lame analogy. We have no alternative, of course, but we should recognize what we are doing.

All this may seem to deny the Biblical notion of the Fatherhood of God. But Maimonides, far from denying it, tried to explain it as compatible with Greek notions of God as a kind of ultimate abstraction totally different from, and indifferent to, mankind. Anthropomorphism, he seemed to say, is true enough for practical purposes and suits the limitations of the human intellect. But to confuse God with our images of him is to defy reason, breed internal contradictions, and invite wholesale denials. We can believe in God only if we recognize our inability to comprehend him.

The Reasonable Mystery

As might be expected, Anselm's argument, that God exists because a nonexistent God would not be the greatest conceivable, appealed to some thinkers but not to others. Among the latter was the thirteenth century's towering synthesizer of ideas, Thomas Aquinas (1225?–1274). As a Dominican monk, he was devoted to Christianity; as a speculative philosopher, he was devoted to the newly discovered Aristotle; and he spent much of his life arranging for the twain to meet in the forum of "natural theology."

He could not accept the suggestion that reality must cravenly conform to human thought. Anselm had seemed to imply, for instance, that the most perfect conceivable unicorn must really exist, since nonexistence is an imperfection. How can the mind's ability to conceive of God as existing essentially guarantee that he therefore does exist essentially? Surely, Aquinas protested, we would have to have a much better grasp of God's essence before we could give any such assurance.

He much preferred a less mystical approach, proposing five arguments for the existence of God from evidence taken from nature rather than from introspection, or from divine revelation. They can be presented here, of course, only in brief, compressed summaries:

> (1) The procession of continual changes that we observe in the universe, with each change preceded by some other (and apparently related) change, must have been originated by an unchanging power existing independently outside that procession.

(2) Similarly, since the series of causes and effects that we observe continues to increase and therefore cannot be infinite, it must have its ultimate origin in an uncaused cause.

(3) Since all things we observe are inherently un-necessary (need not exist), they must be accounted for by some being that is inherently necessary (*must* exist).

(4) The ascending order of perfection that we observe in things must culminate and have its cause in a being of ab-solute perfection (to some, an unexpectedly Platonic argu-ment for Aquinas).

(5) The prevalence of order that we observe in the universe must have its source in a vast, and prior, intelligence.

Although these arguments proved quite durable and can still evoke serious discussion, it later became fashionable, especially after Isaac Newton, to consider them rather naive — particularly Aquinas' rejection of an infinite number of changes and his discerning of an intelligence behind the general order in the universe. But it is worth remembering that accepting the notion of infinite changes implies that the actual number of changes is now a number than which there can be none larger — and that it was yesterday and will be tomorrow. This may be asking more than any number can reasonably bear. As for his perception of a divine intelligence behind universal order, his naivete was shared by Albert Einstein, who found Heisenberg's principle of indeter-minacy uncomfortable on the often quoted premise that "God does not play dice with the universe."

Thus for Aquinas, as for Aristotle, God is Being, without limits or potentialities, fully and eternally existing as the supreme In-telligence. He agreed with Maimonides that human reason is best suited to telling us what God is *not*, and that positive attributes can be ascribed to him only by analogy. He also agreed that the un-changing God is related to his changing creatures only through their relation to him, somewhat as an immovable maypole is related to the shifting positions of the dancers. His ingenuity here, as elsewhere, is notable if not fully enlightening.

He could not accept Aristotle's totally self-absorbed Intellect and still hold to his Christian belief in a solicitous Father redeeming and protecting mankind through his Son and the Holy Spirit; this God must somehow know his creatures and act in their behalf. But *our* knowledge of a thing changes when the thing changes, and surely God's unchanging knowledge could not be so dependent. Then, said Aquinas, God must know his creatures not directly but indirectly, as they exist in his substance, in the eternal Intelligence, where they exist as contingent, changing things without changing that Intelligence. As can be readily seen, Aristotle lost none of his subtlety in translation. Explanations like this require some concentration. They are not likely to dawn on one while, say, running to catch a bus on Madison Avenue.

Furthermore, Aquinas continued, the will of God is likewise directed primarily to his own good, to the divine Essence, and only secondarily to the good of his creatures, which (and who) dimly reflect and thus share in the divine perfection without affecting it. (Aquinas treated the divine knowledge and will as separate attributes, with great discomfort, because he had no practical alternative.) To his orthodox critics' complaints that his theory of eternal, absolute divine knowledge and will amounted to a denial of contingency (that something may or may not occur) and therefore of free will, he replied that God knows and wills some things as necessary and others as contingent. Thus if a person freely commits a sin, God will have foreseen and willed the freedom of that act, without willing its evil consequence.

This brings up again the irrepressible problem of evil. Aquinas considered God to be limited only by absolute impossibility. Since the existence of two infinite beings is such an impossibility, for example, God could not possibly create another God, nor could he create a universe equal to him in his absolute perfection. Since evil is an absence of perfection, it is unavoidable in imperfect creatures, including the operation of imperfect human minds and wills. A human will, even if it "desires" the greatest good for the individual, can be led astray by the intellect's dismaying clumsiness in discriminating between good and evil. *Why* God chose to create this universe is a question that Aquinas considered at least as insoluble as the mystery of the Trinity.

As mention of the Trinity may remind us, the God described here is a detached God, dimly discerned and haltingly explained by human reason, not the responsive God so colorfully revealed in the Bible. Aquinas, like Augustine and Anselm, believed in that revelation and in the authority of the church councils to interpret it. He clearly worshipped the mystical, triune God of the Bible with all his heart and soul. But in his natural theology he strove to worship him, so far as possible, with his mind alone.

This effort has impressed others more than it impressed Aquinas himself. Toward the end of his life, after a mystical experience, he stopped working. All that he had written, he explained, was "like so much straw compared with what I have seen and what has been revealed to me."

The Christian Brahman

Aquinas' disheartening suggestion, that a moment of mystical insight can be worth more than a lifetime of theological study, leads us logically, if fortuitously, to the thought of the fourteenth century's Johannes Eckhart (1260?–1327). Also a Dominican monk, this "Meister Eckhart" taught theology at the universities of Paris and Cologne and eventually became known as "the father of German mysticism."

The rational approach can bring only an indirect knowledge of God, through his effects. Even scriptural revelation is second-hand, passing through the minds of prophets and evangelists on its way to the faithful. But in the mystical experience the knowledge seems a direct and immediate intuition. From such experiences, available only to those of appropriate temperament, a belief has arisen that such mystical visions offer the sole reliable knowledge of God, equivalent to the "beatific vision" enjoyed in the afterlife. A mystical vision, however, is a totally personal and largely incommunicable experience, not easy to distinguish from an hallucination due to peculiar body chemistry or psychic disturbance. Mystics themselves by no means always trust the mystical experiences of others, or even their own. St. John of the Cross once said of a vision-happy nun that she had been talking, not to God, but "only to herself."

Christian mysticism generally has differed from Far Eastern and other more pantheistic varieties in ascribing mystical experiences more to divine activity than to human effort. Thus Eckhart believed that although the human soul could prepare a kind of void by achieving total detachment from "the world," only

God could fill that void. This was partly because he believed in a personal, active God of love, not in an impersonal, inactive Brahman of supreme inscrutability.

Yet this was not all he believed in. Behind this active God he seemed to see a Brahman-like presence, a Platonic "One," which he called the "Godhead." This Godhead, which "flows" through the Trinity and creatures and back into itself eternally, is the real object of union in the mystical experience, since "God" (the Platonic "Mind" or perhaps the "World Soul") is enigmatically subordinate. Indeed, that union could be so complete as to absorb the human soul, making it somehow divine and negating its individuality — a proposition condemned as heretical by Pope John XXII soon after Eckhart's death.

Another point of difference between Brahman, or the One, and Eckhart's Godhead was that union with the latter is a powerful source of ethical conduct. Surprisingly, Eckhart considered good works more noble than mystical contemplation, admiring Martha's bustling, if not her fretfulness, more than Mary's listening in the famous New Testament story. In general, Christian mystics, like Eckhart the preacher and administrator, have not been so much ascetic dropouts from the world as active participants in it, striving to promote the Christian ethic of love.

In Eckhart's view, the Godhead, God's very being, is love. The more closely the human soul is united with that eternal love, the more loving will that soul be. "According to your being," he wrote, "so is your work."

The Reconciling One

As the Middle Ages slowly yielded before the irresistible advance of the Renaissance, the shift in interest from metaphysics to the more worldly sciences introduced some new approaches to divine portraiture. Nicholas of Cusa (1401–1464) was a German-born European cosmopolite, mathematician, philosopher, and cardinal bishop of the church who devised an ingeniously deceptive formula for squaring the circle and fashioned a geometric scenario for the earth's revolving around the sun. His approach, unsurprisingly, was through mathematics.

God's attributes, he suggested, although admittedly quite invisible, can be "seen invisibly" through our observation and contemplation of the things about us in the world. Something very similar occurs in the process of abstraction in mathematics. Although we have never seen an absolutely perfect triangle, we can conceive of it by abstracting it from the welter of triangular things, and we can describe it mathematically. We see it "invisibly" much as we see God's power and beauty in his visible handiwork.

Yet we can see God only "as in a glass, darkly" because he must be beyond all human understanding, conceivable only to himself. Although our inklings of him from nature may be positive, our conception of him must be negative—he is without limits, without blemish, without dependence, and so on. Some positive information is available, but it must be inferred from revelation, which is much less concerned with the nature of God than with his relationship with mankind. From our inklings and inferences we can nevertheless come up with some tentative assertions about the incomprehensible.

One assertion that Nicholas made, with a confidence worthier of a cardinal than a philosopher, was that God is the absolutely maximum being who gives reality to all that we perceive. Thus he is unique in actually being all that he can be. He is the only being that cannot be something else, and in this sense he is all things. He is not identical with any single thing but is the formative principle within all things — the "actualized possibility" of the sun, for instance, the ultimate extrapolation of its various forms of energy. Thus the staggering diversity of the universe, with all its perplexing opposites and contradictions, is formed out of a single uniform reality, somewhat as the great variety of geometric forms arises out of a single thing, the indeterminate line. The relationship between God and his creation thus is one of reconciliation, with the different, discordant, even incompatible ingredients of our world blending, essentially, into the Reconciling One.

However, Nicholas hastily added, this One is also Three. God in his role of all possibility is what we call God the Father; in his role of all actuality, the Son; and in the unity of actualized possibility, the Holy Spirit. In a sense the Trinity is like the triangle, which is the ultimately simple, irreducible geometric straight-line figure from which others derive their being.

This theory reveals a talent for healthful accommodation with church doctrine: Nicholas died peacefully, still a cardinal in good standing. A century and a half later one of his best known and most enthusiastic disciples, another Renaissance man named Giordano Bruno (1548?–1600), also saw God as the One, reconciling all mundane multiplicity in the divine unity. He recklessly carried the idea, however, into the unorthodox realm of pantheism, dismissing the Trinity and the revelation supporting it as myth. He died at the stake.

The Mighty Fortress

By and large, the aim of the theology of the late Middle Ages was not to show that the unprejudiced use of human reason will lead inevitably to faith in God. The goal rather was to demonstrate that reason and faith are compatible: faith, even if unprovable, need not be unreasonable. A great deal of careful thought went into the effort to reach this goal, and a great deal of conscientious argument. The trouble was that this process went on for centuries with little offered in the way of new ideas but very much offered in the way of meticulous refinements. As the proportion of logic-chopping increased, so did the impatience of many religious scholars and teachers. Among these was a German professor of Biblical theology who, early in the sixteenth century, finally decided he'd *had* it. And at least part of the baby, so to speak, went out with the bath.

Martin Luther (1483–1546) was no pussyfooter in his choice of language. He grew quite choleric in his comments on the interference with theology by philosophy, especially Aristotelian philosophy. Human reason in this area, he vividly asserted, is God's enemy — beastly, carnal, mischievous and inane. Aristotle he favored with such lighthearted labels as Stinking Philosopher, heathen beast, three-headed dog, billy-goat and lazy-ass. His lifelong dedication to Biblical theology — for which he was quite willing to employ reason, but only to explain scriptural texts already accepted on faith — may largely account for both his contemptuous attitude and his vituperative nomenclature, since it is no easy task to explain the Bible to students when others may be trying to explain it away. His deepest resentment, however, seems

76

to have been reserved for the Aristotelians' tendency to depersonalize the provident God of the Bible into a desiccated metaphysical Something without a care for mankind in all its hollow heart. Fearful, maybe, but hardly lovable. And certainly not loving.

He was by no means alone. Among his fellow protestants was no less a figure than Erasmus (1466?–1536), that Catholic scholar of catholic interests who shared many of Luther's views — of Aristotle as "a source of corruption," for instance, and of reason as unable to produce any satisfying certitude — and who sometimes matched his vocabulary. But it was Luther who spoke loudest for the proposition that the human soul is united with its Creator not through reason but through that faith which is God's free gift, unearned and undeserved, granted through humanity's loving redemption by Jesus Christ. And of course it was Luther who, largely for reasons beyond his control and of no theological relevance, made the proposition stick — at the least, in many a craw.

His God is the God of the Bible, especially as revealed in the New Testament, through Christ and especially through Paul. This is a God of justice showing his loving mercy by healing the sick, uplifting the lowly, comforting the sorrowful, saving the repentant sinner. He is God Almighty using his power to shield us from satanic forces bent on destroying us, and to rescue us from them when they grow too strong.

This is also, in general, the God of John Calvin (1509–1563), who was a much more systematic Evangelical theologian than Luther ever thought of being. His is a God of sovereign might exercised eternally over everyone and everything, of majestic will creating and sustaining all that is good. It is a transcendent God in touch with his creation through his law. We can know him only through the Christian revelation, and we must accept this message as though he had delivered it himself to each of us directly. The evangelists and other prophets were merely conduits.

God is wholly good, but not his creatures. His human creatures, in fact, are wholly evil. Every human being is born in a state of total depravity, from which a select number are rescued by God's discriminating mercy. No one deserves any happiness,

not even Christ, except as it pleases God. No one deserves salvation, since God eternally predestines each of us to heaven or hell, with no provision for a goat to make a sheep of himself, even with help from a king or a bishop, much less a priest. Church elders and civil officials, however, can and must safeguard the church's integrity by imposing proper discipline.

Discipline, whether proper or improper, is of key importance. When Michael Servetus (1511–1553), physician and scholar of many parts, published his complicated, perhaps impenetrable views on the Trinity — the Word is merely God's self-expression and the Holy Spirit is God's power acting in human hearts — and brazenly denied that God expects civil officials to enforce his moral law, Calvin was outraged. Servetus barely escaped a Catholic burning fete at Lyon by fleeing to Switzerland, where the Calvinist community promptly had him arrested, tried, condemned, and burned alive for uppity theologizing. This may have been a satisfying experience of vindication for the Calvinists, but it was typically ineffective. Many of the ideas of Servetus lived on after him, and today he is considered by many as a precursor of Unitarianism.

For Luther and indeed for the Reformation generally, and maybe even for Calvin, the Deity seems to be most expressively and succinctly described in Luther's famous hymn, *Eine Feste Burg*:

> A mighty fortress is our God,
> A bulwark never failing;
> Our helper he, amid the flood
> Of mortal ills prevailing.

The Perfect Necessity

Anselm's portrait of God as the greatest conceivable and therefore existing being was hung in a neglected corner of the Scholastic theology based on Aquinas, where it gathered dust until refurbished and put on display in the seventeenth century by, of all people, a mathematician. René Descartes (1596–1650), for all his assiduous rationalism, seemed to find this Platonic, almost mystical conception of God completely satisfying.

We cannot get an idea of infinite perfection directly, he wrote, but only negatively, in contrast with limited perfection. We are aware of our unfulfilled desires, and thereby of our defects and limitations, beyond which perfection has a long way to go. At the end of that line is the absolute, limitless perfection that can be ascribed only to God. And this limitless perfection must necessarily include existence, since nonexistence is a limitation.

He conceded that he could think of a perfect winged horse, for example, but denied that it would therefore have to exist. A perfect winged horse can be conceived of as not existing because existence is not of its very nature, but the case is much different with God. We can conceive of a perfect triangle, but not without three angles equal to two right angles. This is a better analogy than those involving such figments as winged horses or unicorns, since a triangle is inconceivable without its three angles. The infinitely perfect God is similarly inconceivable without existence.

Human thought cannot impose necessity on reality. It is the other way around: in this case, the necessity of God's existence fashions the thought, just as the necessity of the three angles and sides fashions the thought of the triangle. Further, he hastens to

add, only one such necessarily existing being can conceivably exist, unlimited by the existence of any other such being. And since God could not ever not exist, he must have always existed and always will exist.

This Platonic approach doubtless arose from his belief in innate ideas, implanted in the mind by God. All clear, distinct ideas, such as the mathematical ideas that so delighted him, he considered to be innate. Also innate is the idea of God as the ultimate, independent, infinite, all-powerful and all-knowing substance (since we could hardly have come up with such an idea out of our own experience). In addition, these innate ideas must be utterly reliable as representations of truth, since the God who created them is without any defect, and our study of nature reveals that "fraud and deception of necessity arise out of some defect."

Such a God could be of great comfort to a professional mathematician.

The Divine All

When Descartes died in 1650, Baruch Spinoza (1632–1677) was a teenager in the Jewish community in Amsterdam, engrossed in the customary study of the Old Testament and the Talmud. Other, less conventional study, including the work of Descartes, led him to suspect that the personal, transcendent Creator of his forefathers couldn't be reconciled with the theoretically infinite God of the rationalists. He finally opted for the latter, somewhat too explicitly to remain unnoticed by the authorities. The scriptures, he maintained to their considerable consternation, were a good practical source of moral guidance but not of truth. In 1656, at the age of 24, he was excommunicated.

Although he presented his ethical philosophy in geometric terms — complete with definitions, axioms and postulates, and with unblushing Q.E.D.'s at the end of his proofs — his conclusions rarely shine with Euclidean clarity. His definitions were arbitrary enough, and his expositions murky enough, to leave generations of contending interpreters struggling in their turbulent wake. His reputation has survived in a colorful spectrum of heated adjectives ranging from "atheistic" to "God-intoxicated."

His definition of "substance" illustrates his rather willful eccentricity: "I understand substance as that which is in itself and is conceived through itself — i.e., the conception of which does not require the conception of something else from which it must be formed." Since most philosophers used the term to denote the essential character of anything, minus its accidental qualities, this cavalier redefinition might be likened to a manic chemist's decision to use the term "marijuana" for H_2O in his technical papers. More

significantly, the meaning of "substance" was changed so that it could no longer be applied reasonably to anything, but only to God. This was Spinoza's starting point: since there could be only one Substance, God and the universe must be the inseparable, indivisible One.

This might suggest that God is beyond any definition, but Spinoza had one to offer: "an absolutely infinite being, a substance consisting of infinite attributes, each expressing eternal, infinite essence." In this unique God, essence and existence are the same. This concept in itself offered no radical departure, but Spinoza was impatient with previous notions of infinity which were not all-inclusive. They limited God, he insisted, by the existence of other realities. But if God is truly infinite, he must be *all* reality.

Of all the divine attributes (as he defined the term, "attributes" are constituents of substance, not additions to it), we can know only two, which he called thought and extension. The former includes human intelligence, which is merely a "mode" of the divine intelligence, and the latter includes all physical reality, which, unlike immaterial reality, has extension and is thus a mode of the divine, unlimited extension. He felt, somewhat like Descartes, that "the clear, distinct ideas in the human mind are as true as those in God." What can be more comforting than the cozy warmth of self-evident truth?

Despite our ignorance of the divine attributes, we do have an "adequate knowledge" of the divine essence. We know enough to recognize that it must include existence, for instance. But we do not know enough to comprehend the divine intellect and will, which cannot be anything like the human intellect and will and must exist in God only nominally. Although we observe changes in the universe, we know that they cannot affect its divine substance, perhaps as the turbulence of boiling water cannot affect the nature of water. Similarly, we observe evil in the world, but we know that it must be merely an absence of good, its "positive" aspect being simply our peculiar way of squinting at it from our self-centered viewpoint.

Our notion of contingency, that something may or may not exist or occur, is also a figment of our deficient understanding. Since God is necessary and is everything, then everything is necessary,

determined, unavoidable and indispensable. (God is "free" only in the sense that he is determined not by something else but by his own unchanging nature.) Human freedom of choice is of course an illusion. So is the human emotion usually called "love of God." Although God cannot love any particular person, he knows and loves himself, and mankind as part of himself. A human love for God is possible only intellectually, in the intuitive sharing in God's love for himself, including mankind. This is our most noble activity, and our "salvation."

This idea of a noble activity has left some interpreters with an uneasy feeling that Spinoza could not entirely rid himself of a grudging recognition of human freedom. He spoke of himself as trying to aim all knowledge toward "the greatest possible human perfection" and of human efforts to achieve a better nature. His acceptance of the Hebrew prophets as sources of moral counsel, though not of revealed truth, also seems to suggest some possibility of human choice.

He surely would have rejected any such suggestion as idiotic. For Spinoza, God and mankind, and everything else, are all inseparably, inescapably One. There is no conceivable alternative.

The Supreme Monad

In 1656, the year when Spinoza was excommunicated from the Jewish community in Amsterdam, Gottfried Wilhelm von Leibniz (1646–1716) was a precocious ten-year-old student in Leipzig, reveling in the heady delights of Greek and Scholastic philosophy. After entering the university at fifteen and encountering the more mechanistic philosophies of his own times, he eventually wriggled free from what he later called "the yoke of Aristotle."

He seems, however, to have been predisposed to some sort of theistic viewpoint. He was thoroughly dissatisfied with the atom-based materialism of Democritus, and he accused the Descartes–Spinoza axis of leading from the one through the other to atheism. A trail-blazing mathematician (discovering the infinitesimal calculus, for example, independently of Newton), he was so impressed by the harmony of the universe that he was convinced it could have nothing less than a divine explanation. The universe, he once ventured, is "God's clock."

Unlike Spinoza, he refused to consider God and the clock as one and the same. Indeed, he seems to have thought of Spinoza as suffering from a kind of philosophical identity crisis; for himself, he was much too confident in his own individual identity to accept the humiliating suggestion that he was merely a mode of God's substance. We get the very notion of finite substances, he insisted, from our awareness that we continue to exist as individuals amid all sorts of accidental qualities and throughout continual accidental changes.

The substances that we perceive are compound substances, composites of simple, elemental substances, which he called

monads. These monads, although resembling the atoms of Democritus as a kind of fundamental reality, have none of the characteristics that we associate with matter: they have no extension or shape, and they are indivisible, like a geometric point. They are, it seems, principles and constituents of existence. Each thing consists of a staggering number and variety of monads, which keep appearing and disappearing as it undergoes change, yet there can be a durable, "dominant" monad that makes the thing substantially what it is. Dominant monads are arranged in a hierarchy of reality, rising through vegetable, animal, and human "souls" to the unique monad at the pinnacle, which is God.

This God can act freely, at least in a sense. He cannot do the absolutely impossible, such as creating another absolutely perfect being, whether it be another God or a flawless universe. He might have freely chosen not to create anything at all. Having freely chosen to create a universe, however, he acted in accordance with his perfect nature by creating the best possible, with the most harmonious arrangement of monads permitted by their imperfections and degrees of compatibility. Leibniz seemed to offer this explanation as a shot in the dark, conceding that the divine freedom surpasses any human understanding.

His notion of "the best of all possible worlds" was to serve as model for the inane optimism of the dauntless Dr. Pangloss in Voltaire's *Candide*. Although Leibniz recognized the existence of evil in the world, as a negation, he held that it was far outweighed by the good; furthermore, it could be a blessing in disguise, resulting in a greater good. He also held, firmly if not very consistently, that the world is constantly improving.

The human will, he proposed, is similarly free: God created the human soul free to choose whatever alternative seems best at any given moment — and thus God, with his infinite understanding of the soul, can predict the choice. This invites a denial of freedom in the making of apparently inevitable future choices, but for Leibniz, as for Augustine, time was only a doubtful human interpretation of an inscrutable reality. God, in his eternal and necessary existence, could hardly be dependent on his clock.

This idea of necessary existence was involved in one of the arguments that Leibniz gave for the existence of God, with an

assist from Anselm. We can think of God as perfect without limit and therefore as necessarily existing. If such a God is possible, he must exist. But such a God is clearly not impossible, and therefore he exists. In addition, the existence of God offers the only rational explanation for the existence of necessary relationships, such as are found in mathematics; for the existence of contingent, dependent things such as we find all about us, including ourselves; and for the harmony prevailing in this imperfect but superlative universe.

Such a splendid clock, he seemed to say, implied a supremely talented clockmaker.

The Perceiving Spirit

Toward the end of the seventeenth century the English philosopher John Locke (1632–1704) had proposed that the human mind, a blank page at birth, is filled with knowledge by experience, solely through the senses. He distinguished between the primary qualities of sensible objects, such as extension and shape, and secondary qualities, such as color and odor. The primary qualities, he suggested, exist in the minds perceiving the objects.

Early in the next century an Irish thinker (and Anglican bishop) named George Berkeley (1685–1753) used Locke's proposition concerning qualities to contradict his proposition concerning the acquisition of human knowledge. Unlike Locke, he wrote a major role for God in his drama. This may not have been his original intention. As the drama developed, however, he found that he desperately needed a *deus ex machina*. Literally.

He denied Locke's distinction between primary and secondary qualities. What Locke had said about secondary qualities, he contended, applied equally to all qualities: they *all* exist in the mind. He next proposed that all sensible objects exist only in the mind. They are simply ideas. Such a proposition is of course both practically doubtful and logically unarguable. Students of Samuel Johnson will recall his kicking a stone in refutation, and frustration.

To exist, according to Berkeley, means to perceive or to be perceived. Spirits do the perceiving, while sensible, material objects are perceived. But from that word "while" there arises a difficulty. Do sensible objects exist only while being perceived? Does the horse in the stable stop existing when the farmer leaves? And then resume its existence when the farmer returns?

Not even Berkeley could live with this apparent absurdity. His solution was to shift the burden to the Christian God that he believed in, assigning him the role of an eternal, omnipresent, all-knowing Perceiver by whom sensible objects could always and everywhere be perceived. Objects thus would need no human observer, be it farmer or philosopher, in order to exist.

Divine and human perception are not exactly the same. The former is perfect and absolute, the latter is imperfect and relative, and differences must be resolved in the latter's favor. Indeed, divine creation consists of implanting the ideas of things in finite minds and sustaining them there, and no mind is in any position to bite the hand that feeds it. Further, God cannot sense things as we do. His perception must consist of immediate and total understanding. God is a spirit like us, but a pure spirit without any of our imperfections and limitations.

Outside formal revelation, God speaks to us through Nature, which is simply a system of symbols busily informing our minds. His moral law is similarly transmitted, but we, imperfect receivers that we are, deviate from it all too often. This is our doing, not his, and we may catch the devil for it. Or vice versa.

Berkeley the Christian ecclesiastic surely had some fairly specific ideas about God. Berkeley the philosophical idealist did not seem much interested in God *per se*. He needed a good, solid prop for his epistemology, and God was the only available candidate.

A similar form of uninhibited idealism was the basis for the religious thinking of a Calvinist divine working the newly discovered territory some three thousand miles to the west. For Jonathan Edwards (1703–1758), the things of this world exist entirely in the mind of God; "spirits only are properly substance." Since this absolutely sovereign mind knows the future from all eternity, every human choice must be inexorably predetermined. This notion left him entangled in the familiar Calvinist thicket, for his preaching revealed a Benefactor who could bestow favors in this life on people doomed, after death, to feel nothing but an Avenger's infinite, eternal wrath amid everlasting fire and brimstone. One of his best-known sermons is entitled, "Sinners in the Hands of an Angry God."

Like Berkeley, Edwards needed an explanation — in his case, an explanation of how people (other people) could be so nasty. And God was the only available candidate.

The Vague Conjecture

The seventeenth and eighteenth centuries generally were a period of awkward transition from an age of faith to an age of reason. Although this traditional view may suffer from traditional imprecision, devotees of Newtonian science clearly had pulled the prayer rug out from under many a pious believer in such comforts as self-evident truths, deductions from first principles, and the inspired credibility of parochial divines.

Many of the divines had themselves greatly hastened the decline of faith with their competitive certitudes, their reciprocal anathemas, their contempt for evidence, and their sour emotionalism. The intolerance of the Reformation turned off a vast number of thinkers whose lean ideas about a Supreme Being and firm dismissals of institutional religion have been grouped historically under the heading of Deism.

In the seventeenth century Thomas Hobbes (1588–1679) was something of a harbinger in his emphasis on political science and his disdain for theological controversy. He was accused of being an atheist (much as people were accused of being "Communist" in America three hundred years later) for guardedly saying we can know *that*, but not *what*, God is, much as Aquinas had said before him. Yet in principle he warmly embraced the Biblical God, quoted the Bible copiously, considered himself a faithful Anglican, and eloquently supported the religious supremacy of the crown.

A few years after him John Locke further widened the horizons with his emphasis on the human mind as a clean slate inscribed only with the stylus of experience. Although he accepted the logical inevitability of a First Cause whose intelligence is discernible in

cosmic orderliness, he considered God incomprehensible even as revealed in the Bible, describable only in negative terms. He was broad-brushed as an atheist by foam-flecked clerical adversaries.

During the eighteenth century several varieties of Deism flourished in France, where the Encyclopedists were cheerfully chipping away at church foundations, and in colonial America, where politicians were more practically building fences between church and state. Both groups were much too busy for any idle speculation about the nature of God in the light of experimental science, but this seems to have been done for them, in spades, by the Scottish philosopher David Hume (1711–1776). Significantly, the subtitle of his *Treatise on Human Nature* described the work as "an Attempt to Introduce the Experimental Method of Reasoning into Moral Subjects."

He evidently found his "experimental" method to be an effective cathartic for the dour dogmatism of Scottish Calvinism, which, being a man of easy-going affable disposition, he found utterly indigestible. But his medicine was little more than that: it was purgative, not nourishing, draining God of character and reality down to a vague conjecture, as evanescent as the Cheshire Cat. He represented a growing dissatisfaction with the clashing portraits of God extracted from revelation by mortally combative organized religions. He considered the God of religion to be a pernicious fancy, and he branded theology as nothing but "hypocrisy and delusion." Under the circumstances, no detailed portrait of God was likely to bear his signature.

Indeed, he had little or no reason to put his signature on anything, since he could see no rational justification for a notion of personal identity, of a "self." He thought of the "self" as merely a continuing series of impressions, of light and dark, heat and cold, chairs and tables, whatever. He showed considerable confidence in these impressions, which he found direct, vivid and exact, and less confidence in their offspring, ideas (especially abstract ideas), which he found shadowy and much less reliable. The idea of cause and effect, for instance, merely reflects our impression of habitual sequence, as when heat predictably evaporates water. As a "natural belief," it is reliable enough for predicting the mechani-

cal processes of nature, but when projected in the direction of a God it fades into total obscurity.

Obscurity seems to have been almost an objective for Hume. Despite his reputation for writing clearly (that is, less impenetrably than most other philosophers), debate has continued to this day over whether he believed in God or did not. More significantly, his predominant theme was the obscurity of reality beyond the reach of sensible experience and concrete experiment. He recognized a predetermined order in the universe similar to the order we see in a manmade machine, but he denied that we can rationally extrapolate to anything beyond, such as an ultimate Craftsman—who, he added, is no more likely to exist than some "eternal, inherent principle of order" equally out of reason's uncertain reach. And even if we could settle on some such intelligent Creator, we cannot thereby reasonably project our own virtues onto him in some highly magnified form. How, for instance, can we know that God is good?

Certainly we cannot infer the goodness of God, he insisted, from the evil in the world. Even if the good outweighs the evil, the evil is so widespread and serious—and apparently so unnecessary—as to suggest either malice or incompetence on God's part. Since God's handiwork thus failed to measure up to Hume's criteria, the idea of its being a consciously designed handiwork was rendered suspect. How this failure is related to his principle of order is not clear, although he seems to have considered the problem simply a matter of degree. At any rate, we cannot reasonably establish that the cause of the universe (whatever it is, if it is) is good, nor that it is evil, so it is probably indifferent, "as far as human understanding can be allowed to judge on such a subject." Nor can we conclude that it is a necessary being, at least "while our faculties remain the same as at present"—faculties of which he took a very dim view.

For all his militant doubting, Hume had little use for total skepticism, which he considered self-defeating. He preferred what he called a "mitigated" skepticism, moderated by "common sense and reflection" and restricting human inquiry to subjects "best adapted to the narrow capacity of human understanding." He was given to using phrases like "it appears" and "it seems," as when he remarked

of animals that "there appears not to be any single species which has yet been extinguished in the universe."

In an era of competitive dogmas, of confident but incompatible assertions of absolute truth about God and mankind, this apostle of uncertainty had an important contribution to make, if only toward the pricking of overinflated balloons. "We know so little beyond common life, or even of common life," he wrote in his *Dialogues*, "that, with regard to an economy of a universe, there is no conjecture, however wild, which may not be just; nor any one, however plausible, which may not be erroneous." This proposition may not be very reassuring; but, in a slough of complacency, that can be precisely its value.

The Categorical Imperator

Hume's reveille call disturbed the sleep of many a philosopher, but of none more than Immanuel Kant (1724–1804), who spoke of his being aroused out of a "dogmatic slumber." Hume's junior by thirteen years, he was a lifelong resident of Konigsberg in East Prussia, where he taught at the university for some fifty years and thereby acquired, in his writing although apparently not in his lectures, a style of exposition celebrated for its academic obscurity.

He did not, however, entirely share Hume's myopically obscure vision of reality beyond sensible experience. Although he agreed that our knowledge comes from sense impressions, he argued that we organize these impressions into knowledge by means of prior mental concepts, or "categories," such as those of space and time. In a limited sense, this was Aristotelian realism infused with Platonic idealism, suggesting once again that there is little radically new under the philosophic sun.

His lack of confidence in sense impressions, and in any human knowledge of a transcendental reality beyond them, led him to deny purely rational arguments for the existence of God. He was especially hard on Anselm's contention that the greatest conceivable Being must have existence, pointing out that "existence" is not an attribute that, like wisdom, must be necessarily predicated of an all-perfect God. The assertion, "God is not all-wise," may indeed be self-contradictory, but not the assertion, "God is not." The former is impossible by definition, but the latter is simply beyond our ken.

Aquinas & Co. also received some lumps, since Kant held that

notions of cause and effect and of universal design are simply "categories" imposed by our minds on our sensible impressions. Since our minds are the source of these notions, we cannot be sure that the arguments based on such notions are related to any external reality. They may be persuasive enough as supporting evidence if the existence of God can be shown by some better argument, but they are quite inadequate by themselves.

He just happened to have what he considered to be a much better argument, based on the moral law that forms the human conscience. This "categorical imperative" imposes obligations on us which we are impelled to fulfill regardless of the temporal consequences. It requires us to behave according to a principle of conduct such that we believe that it ought to be a universal law. Further, it requires that we treat our fellow human beings as ends in themselves, never as means. Two things most greatly impressed him, he once wrote — this remark is engraved on his tomb — "the starry heavens above and the moral law within." Of the former he may have been a bit doubtful, given his mild distrust of sense impressions, but of the latter he seems to have been totally convinced.

This categorically imperative moral law, together with the happiness associated with it (at least theoretically), must as a practical matter have its source in some external agency. Virtuous behavior for duty's sake leads generally and ultimately to happiness (though not particularly and immediately, one must sadly if not sullenly report). It does so by bringing harmony between the world, or "Nature," and the human will. Since human wills, though variously attuned to this harmony, did not create it, we must postulate some prior, independent agency to explain it. This agency is the all-knowing, all-powerful, all-perfect and eternal God.

Such demands on the human will for unremitting dedication to virtue will require some measure of freedom, but Kant's view of sensible impressions, including impressions of human activity, was rigidly deterministic. He tried to slip around this difficulty by explaining that human behavior is predetermined on the level of such impressions but is free on the level of external reality. This awkward idea of a human will engaging freely in predetermined

actions was easy enough to run up a flagpole, but it has never been widely saluted.

Ideas need not be logical to be influential, of course, but they must be needed. Kant's were enormously influential. To his contemporaries who were distressed over God's being nibbled to death by zealous science buffs, he offered an alternative. This was a God who could not be known by unassisted reason but who could be believed in without violating reason. Doubtless this distinction is what Kant was referring to when he wrote that it was necessary for him "to deny knowledge so as to make way for faith."

The Absolute Spirit

Kant's reluctant "denial of knowledge" arose at least partly out of his frustration over the limits of human intelligence. Unlike Hume, who seemed almost to revel in his confinement, Kant sought to escape from these limits. But reason led him too often down primrose paths to contradictory conclusions. The experience of reaching a seemingly valid thesis only to be confronted by its incompatible but equally valid antithesis was more than he could comfortably endure.

Hard upon his heels came another German philosopher, Georg Wilhelm Friedrich Hegel (1770–1831), who offered what he considered to be a reassuring accommodation in the form of "the Hegelian dialectic." Borrowing copiously from his contemporary Johann Gottlieb Fichte (1762–1814), he argued that contradictions are facts of philosophical life, inherent in the development of human thought. We arrive at a thesis only to be confronted by its antithesis, true enough. But we can then analyze the two theses, eliminate the contradictory (or contrary) elements, and merge them into a synthesis — which thereupon becomes a new thesis, starting the process all over again and carrying it into a new area of thought. Thus human intelligence can arrive at some knowledge of things beyond the physical. Indeed, it can deal with the most fundamental abstractions, as when "being" and "non-being" merge into the notion of "becoming." And the process can even lead to an awareness of what Hegel — again borrowing from a contemporary, this time Friedrich Wilhelm Joseph von Schelling (1775–1854) — called the Absolute Spirit.

For Hegel, spirit is the consciousness of other reality and, in its

most refined form, consciousness of self. As might be expected therefore, his God, as Absolute Spirit, resembles Aristotle's Ultimate Intellect, eternally engaged in self-contemplation. But Hegel's God participates much more intimately in the activity of the universe, especially in its spiritual activity, so that human awareness of God is part of God's awareness of himself. Only in such a union can the restless human soul find genuine peace.

This God is a far cry from the remote, indifferent God of Deism, the "natural religion" of the Enlightenment, and from the similarly unknown God of David Hume. Hegel, in fact, deplored the eighteenth-century rejection of religious doctrines. Amid their dismaying welter of contradictions he descried a synthesis, a consensus directed toward the divine Absolute Truth and culminating in Christianity. He found the Christian Trinity quite compatible with his penchant for thinking of things in threes, with the second and third "Persons" representing the Absolute Spirit's participation in, or identity with, the sum total of reality. Accepting the idea of mankind's rejection of God, he considered the divinity of Christ as necessary for reconciliation. Nevertheless, despite his valiant efforts to justify Christian doctrine in general, his Absolute Spirit's participation in the universe is so particular, so detailed, as to deny any freedom to the human will and to associate his infinitely good God directly with the moral evil in the world — and this is a contradiction for which he seems never to have found a handy synthesis.

Indeed, the syntheses produced by his dialectic method were generally not very handy, at least in the sense that other thinkers had trouble getting a handle on them. As a result, interpretations of them have ranged excitedly from right-wing identifications of Hegel's God with the Christian God, feature for feature, to left-wing dismissals of God as an institutionalized absurdity. And of religion as the opiate of the people.

The Focus of Dependence

The Reformation's general emphasis on the divinely inspired Bible as the only reliable source of information about the Creator, in contrast with any human study of his creation — revealed theology vs. natural theology — led naturally to a widespread popular acceptance of a humanoid family consisting basically of stern Father, sentimental Son, and factotum Holy Spirit. Such a notion was dismissed as an addled projection by post-Enlightenment Europe's growing tribe of agnostics and atheists, as might be expected, but it made some Protestant intellectuals very uncomfortable as well. Among the latter was "the father of modern Protestant theology," Friedrich Schleiermacher (1768-1834), who was inclined to agree that the words and deeds of church authorities offered a precarious hold for any belief in a rationally acceptable God.

Being similarly unimpressed by either Kant's moral imperative or Hegel's immanent transcendence, Schleiermacher opted for a God whose attributes "must be taken to mean not something special in God, but merely something special in the way that the [human] feeling of absolute dependence must be related to him." It is surely significant that he was a translator and fervent disciple of Plato and that indeed he sounded like a reincarnated Bishop Berkeley when he wrote that "everything exists by means of God's speaking or thinking it." From this divine idealism he evolved the central idea in his general view, describing God as "the *Whence* of our receptive, active existence."

The "Whence," he added, isn't the world, toward which we have a feeling of some freedom, a feeling much different from our

99

sense of total dependence on God. This universal consciousness of
our utter dependence is unique, comes from God himself, and,
once having been experienced, permeates our daily living. It ac-
counts for our notion of the divine causality behind all the finite
causes, and effects, that we see about us, a causality that is one with
the eternity of God.

The divine eternity, for Schleiermacher, had a rather special
meaning. God is eternal, he argued, but not in the sense that he
is "beyond" time, as though time could have its own separate ex-
istence. Rather, God is time-less, with the privative "-less" used
somewhat as in such words as "weightless" or "expressionless." The
concept of time is simply void of meaning with respect to God. It's
meaningful only to us in our dependence on him.

As with the eternity of God, so with his omnipresence. It is not
that he fills all space but that he is space-less. His causality is the
condition not only for objects in space but also for space itself. The
assertion that God fills all space, like an infinitely expansive gas,
is of course not meant to describe a physical phenomenon, but it
"is rarely interpreted with appropriate caution." As for the phrase,
"the immensity of God," Schleiermacher seems to have reacted
with immense impatience. Why use the word, he suggested, when
"immeasurability" is available and more applicable to time and
space?

He apparently considered this distinction important to his cen-
tral idea: God's attributes can be rationally described only within
the bounds of our totally dependent human understanding, and
what thimble can hold the sea? The most we can really say of God
in this case is that he is measure-less. Our feeling of dependence
demands that he be completely *in*-dependent.

Thus in a sense, curiously, the attributes of Schleiermacher's
God depend on our understanding of them, or on our lack of
understanding. What they gain in rational acceptability they lose
in emotional appeal, such as that exerted by the vivid God of the
Bible. Whether the balance be gain or loss — and surely this
depends greatly on very personal needs and inclinations — one can
hardly imagine Schleiermacher's God arguing with a difficult
Moses over the details of the prophet's latest assignment.

The Personal Absolute

Hegel's influence on the course of philosophy was never matched by his transient friend and professional rival, Friedrich Wilhelm Joseph von Schelling, to the latter's considerable chagrin. Schelling's opinions were, for one thing, too mercurial to make a solid impact. He changed his mind so often throughout his career that he came to be called the Proteus of German idealism. More poet than philosopher, he shifted with the tides and currents of his life and times. Personal misfortune and discouragement, for instance, seem to have turned him late in life to the comforting personal God of Christianity. And his tossing and turning, combined with his taste for mystical and esthetic conjecture, earned him an exalted status in the annals of obscurity.

By the time of his death in 1854 (almost a quarter of a century after Hegel's), Schelling had developed a distinction between two approaches to the idea of God. The negative approach uses reason alone to arrive at the idea — "negative" apparently because it tends to deny, or at least to divorce God from, any other reality. The positive approach is more empirical, reaching the idea of God after examining the world and its history, especially the development of mankind's awareness of God. He modified his early idea of God as a kind of Aristotelian self-contemplating Absolute, blissfully absorbed in its own identity, to accommodate the notion of a personal Creator gradually revealing himself in both works and words. This self-revelation, he decided, was at first expressed not only in the physical world but also in the fanciful symbols of mythology. The mythical grains of truth then flowered in the divine words of the Bible and especially in the words and person of Jesus Christ.

As this historical concept may suggest, Schelling was much more comfortable than Kant or Hegel with contradictions. He used such phrases as "eternal time," and the "eternal beginning" and "dual unity" of God, with disconcerting assurance. Indeed, he considered contradictions indispensable to any kind of vitality: without contradiction, he maintained, there could be nothing but a permanent, immobile, featureless mishmash. An absolute God can therefore relate to his creatures much as they relate to one another. His nature is absolute and necessary, but not his activity. While existing in an "uninterrupted circle" of eternity, he "wishes" to reveal himself through particular events in time.

Such events can even include instances of suffering, which is unavoidable in freedom, and God is "necessarily free." Even the Absolute Being must suffer in order "to understand its own depths." Suffering in general, Schelling explained, "is the path to glory, not only for mankind but also for the Creator." Creator and creature thus participate in suffering, and the world is "nothing but" the pulsating heart of God. Such elaborate conceits as this last could hardly be expected to enhance a philosopher's reputation for disciplined thought.

This view of suffering reveals, of course, the influence on Schelling of Christian theology, particularly its mystical notion of suffering in the Second Person of the Trinity, although he seems to have carried the doctrine far beyond its implications. Further evidence of this influence can be seen in his interpretation of human history as an Iliad and Odyssey, with mankind alienated from God in the fall from grace and then reconciled through the mediation of Jesus Christ.

If Schelling, in responding to this influence, had more severely restrained his imagination than he did, he might have made a more enduring contribution to the history of God. Instead, in the opinion of many philosophers, he simply went off the deep end. His descriptions of God are reminiscent of Hamlet's teasing discussion with Polonius on the shape of a cloud.

The Redeeming Teacher

Schelling's audiences at times included a student of theology from the university at Copenhagen named Søren Kierkegaard (1813–1855), who was destined much later to be called, rather loosely, the founder of existentialism. He thoroughly shared Schelling's uneasiness over Hegel's "negative" neglect of particular, concrete reality, and he was repelled by the Hegelian tendency to confuse the infinite Creator with his finite creatures.

Any such confusion was intolerable to Kierkegaard the existentialist, for whom each human creature's separate identity and fulfillment was of first importance. His interests lay not in describing the Creator—this, he seemed to feel, had already been done well enough by Judeo-Christian revelations and traditions—but lay rather in establishing the relationship between the human creature and the divine Creator.

That relationship, he decided, requires an intense personal commitment from the human spirit. Reason alone cannot provide the absolute certainty needed for this whole-hearted commitment (although his praise for the noble death of his hero Socrates seems to contradict this view). Human intelligence, left to its own meager devices, cannot reach the requisite level of secure information concerning the existence and attributes of God or one's own relationship with him. But faith can. To pass from the enervating anxiety of probability to the exhilarating tranquillity of certainty requires a "leap of faith" from the morass of sinful ignorance to the firm, high ground of personal enlightenment.

This enlightenment in turn requires the services of a divine Teacher to complete the individual's redemption from his or her

previous sorry state. Therefore the infinite, sublimely transcendent God, totally inscrutable to reason, and totally unlike any human person, took on a human likeness and indeed became human, in order to instruct humanity on how to achieve eternal fulfillment. Like the leap of faith, each individual's acceptance of this instruction is an act of will, not of intellect, and must be expressed in conduct conforming to the divine precepts. The process is one of incessant striving, of "becoming" rather than of "being." In this connection he charged that institutional Christianity encourages stuffy group complacency, a resting on unearned laurels. Insofar as it does, it distorts the Teacher's message.

That message, he maintained, is addressed to each individual, not to an institution or to mankind in general. It comes from a Creator mysteriously transformed by his love for each of his creatures, who must return that love as individuals, freely, without the constraints or illusory comforts of institutional security blankets. In this sense Kierkegaard's God is an intimate God, accessible through assiduous personal attention and obedience to his teaching.

Yet this is also a remote God, transcending his creation. Evidently reacting against Hegel's near-pantheism, Kierkegaard put great emphasis on the infinite gulf between God and mankind, bridgeable only by the infinite power of divine love. His existentialism was a philosophy of self-fulfillment centered on Christ. In later versions that center would disappear, to be supplanted by the all-encompassing self.

The Blind Impulse

Hegel and Schelling were critical of each other's work, but their criticism was downright affectionate in comparison with the scorn heaped on both of them by Arthur Schopenhauer (1788–1860), who was German philosophy's foremost prophet of doom and gloom. Their easy tolerance, indeed their embrace of Christianity's God aggravated his chronic dyspepsia beyond endurance, and their suggestions that life might be tolerable he found utterly intolerable. Since his general viewpoint is hardly an attractive one, his work received little notice until the last decade of his life, when the apparent failure of the revolutions of 1848 created an atmosphere of discouragement in which a philosophy of unrelieved pessimism, particularly one embellished by a sharp pen and gritty wit, could be not only more acceptable but even fashionable.

He offered no portrait of God. Instead, he denied everyone else's. But, in doing so, he had plenty to say on the subject. The kernel of his opinion on the existence of God can be found in a single, if rather extended, sentence. The wretched makeup of this world, he wrote, "in which living things survive by feeding on one another, the resulting misery and fear of everything alive, the profusion and enormity of evil, the diversity and inexorability of suffering that often reaches the level of calamity, an onerous life hastening to a bitter death — this cannot be ascribed to a single all-good, all-wise, all-powerful Source. It is easy to raise a furor against this view but hard to answer it with solid arguments."

Having thus dismissed the God of traditional Western theism, he could hardly be expected to have a very high opinion of pan-

theism (although later in life he was emotionally attracted to Hinduism and Buddhism). To call the world "God" is merely to introduce a needless synonym for the word "world." The fancied progress from theism to pantheism, he declared with characteristic diffidence, is simply a move from the unproven to the utterly ridiculous. If anything, it "would be far more accurate to identify the world with the devil."

In such a world happiness is a negative thing, merely offering some brief respite from the general anguish (as in the contemplation of art). Schopenhauer's view of dialectical progression was more Sisyphean than Hegelian: even a brief respite soon becomes tedious, and the tedium compels the will to find an alternative, which brings on further anguish. Obviously, life is a very vicious circle.

Is there, then, any kind of "ultimate" reality? For Schopenhauer, it seems to have been an all-encompassing, all-infusing Will-to-Live, especially the universal, unrelenting, blind desire behind self- and species-perpetuating activities like eating and breeding. The world we know is a visible expression of this irrational energy, and our gods, or Gods, are visionary expressions of the wishful thinking that this energy occasions in mankind. So, too, are the illusions of free will and eternal life. There is no escape from the treadmill except through death, or perhaps through that rarity, total asceticism.

Maybe we should be thankful that Schopenhauer did not believe in God. It is painful enough to read him as it is. Any kind of personal God that he might have come up with would surely have been, quite literally, a Holy Terror.

The Projected Self-Image

Among the works of Hegel's students which litter the landscape of nineteenth-century philosophy are those of Ludwig Feuerbach (1804–1872), an early proponent of scientific humanism whose thinking formed something of a bridge between Hegel and Karl Marx and was a harbinger of Sigmund Freud.

He is counted among the extreme "leftist" offshoots of Hegel largely because he managed to turn the master upside down. Where Hegel had considered the Absolute Spirit to be the only genuine reality and had relegated all else to the dim realm of appearances, Feuerbach looked on the "all else" as the only reality and the Absolute Spirit as no more than a useful hallucination. There is no reality beyond the material, sensible world of human experience. Human intelligence, apprehending this world, at first invested it with limited projections of the human personality—the sprites and hobgoblins and various godlings of primitive animism. Eventually, however, as humanity became more self-conscious and contemplative, it consolidated these into a single projection, a Being possessing human qualities without their frustrating limitations. This imaginary God thus has supreme intelligence and will, and is a distillation of the love that humans can feel for one another. It is a God of love, but of human love projected on the void.

Love, Feuerbach had concluded, is better than hate. The illusory God of organized religion, having been the source of (or reason for) so much intolerance and hatred throughout history, must be summarily denied. Thus the God of "faith" is repugnant, the God of "hope" is merely a product of wishful thinking, and the

God of love is only a heady reflection of human love at its best. As for a personal God, that's all very well as an imaginary extension of a strong human personality; but to make God a real person, he complained, is like mixing strong German beer into the nectar of Olympus "to give it a solid base." Denial of a personal God is simply "scientific candor." So drink the beer, and dream of the nectar.

An imaginary God like this can be many things, at different times or all at once. Feuerbach defines God variously, in human terms of course, as feeling, as reason, as imagination, as any of his attributes, as love. God is whatever mankind makes of him, like the vision that prompts a painting or a piece of sculpture. God, in short, is mankind, both the subject and the object of human imagination. He is the epitome, but not the embodiment, of human love.

Many a philosopher in the past had felt that an infinite, absolute God could have no relationship with mankind. Feuerbach's God *is* his relationship with mankind.

The Inadequate Good

While some philosophers were seeking refuge from uninhibited rationalism in the comforting mysteries of imaginative idealism, others were trying to come to terms with the impudence of scientific inquiry. Among the latter in the early nineteenth century, two of the most ardent conciliators were the Utilitarians Jeremy Bentham and James Mill, who defined all value simply as usefulness in producing human happiness for both individual and community. Dedicated to the wisdom of unadulterated reason and to political and social reforms widely resisted by the religious bureaucracies, they showed little interest in any God advertised by such bureaucracies. James Mill, in fact, sourly described institutional religion as "the greatest enemy of morality."

A less ardent but more articulate and much more famous Utilitarian was James's son, John Stuart Mill (1806–1873). Grist for this Mill included more than the rational element in human nature. That nature clearly is rooted in prose, he argued, but we can't ignore its reaches into poetry. Reason must indeed be emphasized, but not to the rigorous exclusion of everything else. Even religion.

And so he did not share his father's nose-wrinkling perception of the role of religion. He recognized that religion historically had proved excruciatingly useful in promoting quite the opposite of human happiness, perhaps more often than otherwise, yet he was convinced that at times it can provide and has provided humanity with a fulfilling happiness, sometimes with a happiness that seems to transcend the human condition. It also provides some ideals — through the words and example of Christ, for instance — which fit

quite comfortably, for all practical purposes (the only worthwhile purposes), into Mill's conception of utility.

As might be expected, Mill had a similarly dispassionate view of God. Since he agreed with John Locke that all our knowledge comes from sensible experience, he tended to dismiss any argument for the existence of God that smacked of metaphysics, a discipline which he thought of as bloated with undisciplined conjecture. The argument from design, however, struck the chord to which he was most delicately tuned: it is, he wrote almost enthusiastically, "an argument of a reliably scientific character, ... wholly grounded on experience." Being inductive in procedure (Mill naturally disdained purely deductive reasoning), it is a rationally acceptable approach leading to a useful measure of confidence — a confidence which, in the case of the argument for the existence of God, Mill felt amounts to "a large balance of probability."

Yet this very argument, he added, militates against the idea of an all-powerful God because it reveals a God using means to achieve ends. A truly all-powerful God would achieve his ends directly. The use of means is an acknowledgment of limitations, of needing something in the sense that a carpenter needs tools. The sun, as sustainer of warmth and life, has often been taken as a symbol of God's power; but, as an instrument performing that function, it reveals instead the limits of that power.

Mill argued further, and more cogently, that, given the existence of evil in the world, God cannot be both all-powerful and all-good. Like us, he has his limitations, including the limits on his ability to inspire confidence. Belief in such an intelligent but finite Deity, who desires our welfare more fully than he can provide it, is not totally unreasonable. It constitutes a "rational skepticism" hovering somewhere between total rejection and unconditional acceptance. For a predominantly reasonable person, this level of assurance will have to suffice; since it can promote human happiness, it can be "useful." A more emotional person is free to opt for, say, Bing Crosby's (or Johnny Mercer's) advice in *Going My Way*, to "accentuate the positive, eliminate the negative, and don't mess with Mr. In-Between." But that's not for the likes of John Stuart Mill.

The Pervasive Consciousness

As the heyday of German idealism began to wane, the Platonic notion of a World Soul resurfaced rather flamboyantly, in the work of German scientist Gustav Fechner (1801–1887). From a background saturated in biology, physics and mathematics, and from pioneering work in psychophysics (the study of sensations and their stimuli) and in experimental psychology, Fechner emerged with an arduously crafted portrait of his Maker.

His starting point reminds one of Albert Einstein's effort to come up with a unified field theory that could include electromagnetic, gravitational, nuclear, and all other forces in a single expository equation. Fechner was deeply impressed with the power of gravity, with its universal invariability, its all-inclusiveness. Identical bodies, he pointed out in a tone of fascinated amazement, will attract each other identically "whether right here or a trillion miles away." This mysterious power is rigidly deterministic in the sense that its effects are always the same under the same conditions, yet it permits immeasurable freedom in the sense that its effects can be vastly different under different conditions. An unchanging power thus gives rise to ceaseless change. Such a power, he felt, justifies our considering the universe as the physical aspect of God, much as we consider the body as the physical aspect of a human being. The human body, indeed, being part of the physical universe, is thereby part of the physical aspect of God.

However, as nearly everyone recognizes, the body is *only* the physical aspect of the human being. Another, more important aspect is that of consciousness. Fechner, being at least as fond of

analogy as Plato, extended the phenomenon of consciousness in both directions: from humanity down through animals and plants and even to what are generally called inanimate objects, in diminishing degree; and from humanity up to the supreme, infinite, incomprehensible consciousness of God. Just as the physical aspect of God pervades the physical aspect of the world, the spiritual aspect of God pervades the spiritual aspect of the world.

Thus Fechner's "panpsychism," unlike pantheism, stopped short of defining all reality as God. It offered rather a progression of reality from the passive stone to the supremely active God. And in this Fechner also saw a progression of freedom. Any activity in a stone is determined solely by forces outside the stone. But in the plant, animal and human levels (in that order) one can detect an increasing element of self-determination, a rising degree of freedom from external influence. Fechner readily extrapolated this progression to the absolute freedom of God.

He observed such a progression also in the individual, with the passage of time, as in the development of the very dependent child into the much more independent adult. This is accompanied by a progress in perfection, as when (if too rarely) the self-love of a child is transformed, in the adult, into a nobler love for another. All perfections, human and otherwise, have their ultimate form in God. But by "ultimate" Fechner meant "ultimate as of now." For God is forever progressing in perfection.

At this point the seas of analogy get pretty heavy for any ordinary sailing, with the reader thoroughly drenched in billows of metaphor and paradox. Fechner considered God — to whom he ascribes the conventional attributes of omnipresence, omniscience, creative omnipotence, and so on — as continuously progressing from lesser to greater while proceeding from "earlier" to "later" stages of development. Yet at each stage of development God is infinitely great because at any stage there is nothing else to equal him. Thus the "later God looks down merely on himself," on the earlier God, in whom this later God nonetheless recognizes the potential that "raised him to his present eminence." This heavily freighted concept of divine progression without beginning or end puts quite a strain, to say the least, on fragile human notions of time and infinity.

Although God may progress forever in perfection, Fechner had to concede that evil exists in this imperfect world. He was puzzled about the origin of evil, although he felt that its existence is probably inevitable amid imperfect individuals. He refused to ascribe its origin to the will of the Creator, proposing rather that its existence offers God endless opportunities for transforming it into good. He seems to have felt that if evil did not exist, God would be forced — or at least eager — to invent it. God, he suggested, can't operate in a vacuum.

Similarly, he believed that God feels suffering — not God's, but ours. The difference is that, unlike us, God in anticipation also feels the joy that will eventually replace it. As God is the ultimate source of all human satisfaction, so is he the source of all comfort. Whoever is suffering, Fechner maintained, will find the greatest comfort in thinking of God.

Fechner himself experienced a good deal of suffering in the latter part of his life. Among other things, he became partially blind, and his eyes were painfully sensitive to light — probably as a result of looking at the sun during his study of visual after-images. We can hope that he found the kind of comfort he recommended. Certainly he spent a great portion of his time thinking of God.

The Dead Illusion

While (or soon after) Fechner was laboriously painting his generally flattering portrait of God, Friedrich Nietzsche (1844–1900) was furiously burning all such portraits in smoldering prose. Europe was, he wrote gleefully, finally waking up to the perfectly obvious fact that God was dead — and should be. The belief in the God of the Jews, he complained, is the source of everything that says *no* to life, and the belief in the triune God of the Christians is simply three times as bad.

God is an illusion created and maintained by those with a vested interest in him, the priests. Consider the fable that they concocted for the Garden of Eden (as properly interpreted in *The Antichrist*). God, strolling in the garden, realizes that he's bored. So he fabricates a man to provide a little amusement. But it turns out that the man is bored, too, and thereby boring. So God provides him with some other animals in the hope of making him a little livelier. But the man's still bored, so God provides him with a woman. This, however, proves to be just one more mistake, the worst mistake of all, since the woman introduces the man to science, to human knowledge, wherein lies the benign virus that threatens God's death, his disappearance, his elimination by human intelligence.

God, thoroughly alarmed, takes the precaution of ejecting the impious couple from the garden and introducing copious evils into their lives, and the lives of their offspring, in order to distract them all from any pursuit of knowledge ("Thou shalt not know"). His favorite distractions are disease and war, which keep humanity much too busy to examine his credentials (which of course are

114

really the credentials of the priests). And so it goes, one gathers, until the latter part of the nineteenth century, when the growing power of science begins to erode God into oblivion. Him and his cunning, cowardly, bloodsucking priests.

If the idea of God grew out of this human ignorance fostered by distraction, it took its chief nourishment from the fertile soil of humanity's built-in masochism, from the chronic addiction to guilt and self-punishment encouraged assiduously by the priestly pushers of one of Europe's two most powerful and widespread narcotics, Christianity (the other being alcohol). Thus the poor victim "of a guilty conscience uses the basic assumption of religion to convey his self-sacrifice to its fearful extremity," imagining every nasty prohibition etched in his own nature to be a law outside himself, an eternal law to be violated only at the risk of cruel and unending punishment decreed by a divine judgment. This, Nietzsche explained, is "the origin of the 'holy God.'"

This God is a figment of the theologians, who are congenital, inveterate, professional liars. Spiders, Nietzsche called them in a metaphor familiar today to devotees of Ingmar Bergman's *Through a Glass Darkly*, spiders who spun their webs about this figment until God himself became a spider, spinning out the world. Nevertheless, however cunning and elaborate their constructions, God is really nothing more than a deification of the void.

In contrast, the goal of humanity, in the ceaseless expression of its will to power, its drive for dominance, must be an equally mythical but much more admirable Superman, the ideal paradigm of the best in human race. This ideal is unattainable because each life must be lived in every detail over and over again, in infinite recurrences. But Nietzsche, as well as the many others on whom he seemed to exert an almost hypnotic influence with his glib and visionary literary style, considered it a much more stimulating alternative to the weak, life-denying God of a decadent Christianity.

The battlefields of philosophy and theology are strewn with the remains of straw men. Nietzsche's favorite straw man was the sour God of the proselytizing ascetic, the merciless God of the professional sermonizing castigator, the spider God in the giant web of suffocating taboos. Although his exclusive concentration on (and

enlargement of) these repellent images may be puzzling, his impatience with them is certainly understandable. Both his focus and his irritation may be at least partly explained by one of his aphoristic comments in *Human, All Too Human*. Sometimes, he wrote with characteristic gentleness, "one remains true to a cause simply because its adversaries won't stop being stupid."

The Limited Hypothesis

Fechner's idea of God as a pervasive consciousness struck a vibrantly responsive chord in William James.

The famous psychologist (1842-1910) felt that religious and other psychic experiences had been deplorably neglected as data for investigating and explaining the world about us. "Those who have such experiences distinctly enough and often enough to live in the light of them," he reported in *A Pluralistic Universe*, "remain quite unmoved by criticism, from whatever quarter it may come.... They have had their vision and they *know* — that is enough — that we inhabit an invisible spiritual environment from which help comes, our soul being mysteriously one with a larger soul whose instruments we are.

"One may therefore plead, I think, that Fechner's ideas are not without direct empirical verification.... The analogies with ordinary psychology and with the facts of pathology, with those of psychical research, so called, and with those of religious experience, establish, when taken together, a decidedly *formidable* probability in favor of a general view of the world almost identical with Fechner's."

The word "probability" here is significant, even with the italicized "formidable" in front of it. However great James's enthusiasm for Fechner's "panpsychism," his pragmatism reined it in. For James, "truth" is whatever fits, or adequately explains, the facts as currently known. Thus the Ptolemaic system was true, or true enough, before Copernicus, as was Newtonian physics before Einstein. Hypotheses about God may be evaluated tentatively as more or less probable, but they will change as new information

accumulates — and "all the evidence will not be 'in' till the final integration of things, when the last man has had his say and contributed his share...." Until then, God is only a formidable working hypothesis.

And an indispensable one. For James, the normal human psyche demands some rational hypothesis in order to function (and function it must). No world view that fails to meet this essential need can ever gain widespread support. "Materialism and agnosticism, even were they true, would never gain universal and popular acceptance; for they both, alike, give a solution of things which is irrational to the practical third of our nature, and in which we can never volitionally feel at home." Theism at least gives the "theoretic faculty" something to go on. Not something to *rest* on, however, since ordinary human judgment is constantly vacillating. If it finds itself drifting into a complacent, dogmatic, idolatrous theism, it will be brought up short by its respect for concrete facts; and if it finds itself drifting into a similarly complacent acceptance of such facts merely "in their simple mechanical outwardness, up starts the practical reason with its demands, and makes *that* couch a bed of thorns."

The God of this theism is substantially Fechner's, although James could not bring himself to follow panpsychism into the dark recesses of inanimate objects. Nor could he accept God as all-enveloping: "Psychologically, it seems to me that Fechner's God is a lazy postulate of his, rather than a part of his system positively thought out.... Whenever Fechner tries to represent him clearly, his God becomes the ordinary God of theism, and ceases to be the absolutely totalized all-enveloper." The fly in Fechner's ointment is the problem of evil, which he consistently solves "by making his God non-absolute." With this solution James thoroughly agreed, as firmly as his general tentativeness would permit. Intellectually, he proposed, the "line of least resistance" apparently would be to accept Fechner's notion of the superhuman consciousness but not its absolute universality — to accept "that there is a God, but that he is finite, either in power or in knowledge, or in both at once."

James failed to deal comprehensively or incisively with this idea of a finite God and with the arguments against it. Perhaps he

too was guilty of "a lazy postulate." Certainly he was impatient with the intricacies of traditional scholastic arguments for the existence and attributes of God. Such arguments, he concluded, "fail to constitute a knockdown proof," justifying "a definite good-by to dogmatic theology."

Nevertheless, the God on which he apparently came to rest — still tentatively, of course, but not uncomfortably — seems very much like a diffused reflection of a traditional Western God, a God of unimaginable power and unique personality, a Creator separate but by no means totally divorced from his creatures. "In whatever respects the divine personality may differ from ours or may resemble it, the two are consanguineous at least in this — that both have purposes for which they care, and each can hear the other's call."

The Analogous Mind

One of William James's colleagues, and a good friend, was New Englander Charles Sanders Peirce (1839–1914), an intellectual virtuoso who did significant work in such varied disciplines as mathematics, semantics, logic, metaphysics, psychology, astronomy, cartography, geodesy, spectroscopy, metrology and also (incredibly) computer circuitry. It was largely from Peirce that James and others extracted their competitive doctrines of pragmatism, in such diverse profusion that Peirce renamed his brainchild "pragmaticism" on the assumption, he explained, that anything with such an awkward name should be safe from further kidnapping.

Since he took the trouble to compress his concept of God into a single sentence ("single" by nineteenth-century standards of English prose), perhaps we should have the decency to grant it a hearing: "If a pragmaticist is asked what he means by the word 'God,' he can only say that just as long acquaintance with a man of great character may deeply influence one's whole manner of conduct, so that a glance at his portrait may make a difference, just as almost living with Dr. Johnson enabled poor Boswell to write an immortal book and a really sublime book, just as long study of the works of Aristotle may make him an acquaintance, so if contemplation and a study of the physico-psychical universe can imbue a man with principles of conduct analogous to the influence of a great man's works or conversation, then that analogue of a mind — for it is impossible to say that *any* human attribute is *literally* applicable — is what he means by 'God.'"

Others will say, Peirce continued, that the analogy has a

120

terminal limp because the "mind" of God is so totally different from the human mind as to make the comparison meaningless. "This is not so," he stoutly replied, "because the discoveries of science, their enabling us to *predict* what will be the course of nature, is proof conclusive that, though we cannot think any thought of God's, we can catch a fragment of His Thought, as it were." The "as it were," unfortunately, hardly invites much confidence in the "proof conclusive."

It is surprising that a man of such mental stature, a man trained in and committed to the rigorous discipline of the physical sciences, could write about God in such a bold yet unsteady hand. He did so, however, habitually. His belief in the existence of God was founded on what he called the Neglected Argument, which he thought of as arising naturally from the playful musings of a mind at leisure. In such aimless contemplation of the wonders of the universe, "the idea of God's Reality will be sure sooner or later to be found an attractive fancy, which the Muser will develop in various ways." The N. A., as he actually called it, although it was too lively and too disorganized an argument (he felt) to appeal to a professional theologian, was quite persuasive enough to "convince any normal man."

Indeed, he seemed to think of other, more pedestrian approaches as strewn with the rubble of logic-choppers. He considered the heart far more reliable than the head. "Now the only guide to the answer to this question," he pluckily wrote, the question being whether God really exists, "lies in the power of the passion of love which more or less overmasters every agnostic scientist and everybody who seriously and deeply considers the universe. But whatever there may be of *argument* in all this is as nothing, the merest nothing, in comparison to its force as an appeal to one's own instinct, which is to argument what substance is to shadow, what bed-rock is to the built foundations of a cathedral."

He further believed in this God as the Creator of the three universes of human experience (luckily we need not go into *that*). As necessary, too, and timeless. And as all-knowing and all-powerful, but only vaguely, since "we only wildly gabble about such things." Curiously, although he envisioned a personal and even communicative God, this God is essentially a disembodied

spirit; therefore, since consciousness is a totally physical, even visceral, phenomenon, "God probably has no consciousness." The functions of human consciousness, he felt, are greatly overrated, and need not be extrapolated to God.

His belief in a Creator placed him in opposition to some aspects of the Darwinian theory of evolution, which in his day was making it big in the drawing-room circuit. But this opposition, he contended, was merely a figment of the public imagination: Creation and evolution are quite compatible. This notable contribution to a cooling of the controversy was to be sadly neglected over the next several decades of pious religious rancor.

The Eternal Insight

Among the advanced students of philosophy at Johns Hopkins University in the late 1870's, enjoying the lectures of both James and Peirce, was Josiah Royce (1855–1916), a former engineer from the University of California who had become engaged in more speculative pursuits in the invigorating intellectual climate of the Eastern seaboard. His success in this engagement led him to thirty-four years of teaching philosophy at Harvard University and his appointment there, in 1914, to the prestigious Alford chair of philosophy. Like James and Peirce, he was something of a Renaissance man, gaining recognition in several fields, including sociology, psychology, history, literary criticism, mathematical logic, and metaphysics.

An admirer of Hegel, he had a taste for undiluted idealism, arguing for an absolute truth against dedicated skeptics by pointing out that an absolute denial of absolute truth implies a childlike faith in it. As might therefore be expected, his God resembles Hegel's Absolute Spirit, although not absolutely, being also somewhat analogous to Peirce's Analogous Mind.

His approach to the Absolute was through the recognition of the existence of error. If I make a judgment, I can determine whether it is true or false only by referring to a deeper, broader insight such as a more perceptive and knowledgeable person might share with me. But then *that* insight will have its limitations and must be evaluated against a still deeper and broader insight. And so it goes until we reach an unlimited insight, a divine arbiter of truth and falsity. "The whole world of truth and being must exist only as present, in all its variety, its wealth, its relationships, its

entire constitution, to the unity of a single consciousness, which includes both our own and all finite conscious meanings in one final eternally present insight."

Thus Royce, unlike Peirce, thought of God as conscious — self-conscious, if you will, since God and the world are One. And as all-knowing, fusing fact and idea into an eternal awareness of "the complete, the fulfilled answer to every genuinely rational question." And as experienced, in a sense and to a degree beyond our understanding, experiencing what we experience, but actively, immediately, and all-inclusively.

This pantheism confronted Royce with the irrepressible problem of explaining the existence of evil. To his credit, he refused to cringe behind the venerable veil of illusion — "it's all in the mind" — but, instead, sturdily proposed that evil really exists, though only as the villain of a perpetual play in which the good forever triumphs. Through the power of God, "evil ought to be and is endlessly thwarted, endured, but subordinated." Human suffering is divine suffering, which is necessary to complete, to fulfill the divine perfection. If a human being can endure suffering, why can't God?

As for moral evil, the human will is one with the divine will, but moral evil disrupts that union until perfect love can restore it. All evil "exists only that it may be cast down." This union of the human and the divine will is the goal of both (if "both" can be used in this context), although the human will can freely choose a wrong means to that end and thereby get dismally sidetracked.

The possibility of permanent, willful, obstreperous sidetracking is a problem that Royce seems to have sidestepped. One can hardly blame him. In view of the age-old intractability of the problem, who will cast the first stone?

The Molder of Chaos

While the American thinkers were playing their roles of Procrustean host to an unprotesting Deity, an Austrian-born professor of philosophy at the German university in Prague was similarly occupied, although somewhat more feverishly. Christian von Ehrenfels (1859–1932) offered what he called "dualistic theism" in opposition to "solotheism." He described the latter disdainfully as "the view of the world that sees God as the single, sole universal principle and that reaches its climax in the proposition, repeated time and again over the centuries, astounding in its impudent paradox, that 'God made the world out of nothing.'"

Ehrenfels' alternative to nothing is timeless, limitless Chaos (thus capitalized, literally, out of love and respect). A world without beginning, he felt, was highly improbable, especially when one considered the emphasis on galloping entropy then coming into scientific vogue. (If the world is heading toward a destiny of featureless goo, it cannot have been doing so for an uniimited time, or it would long ago have reached that unappetizing condition.) Nor could he readily accept the discouraging Kantian proposition that puny human reason has no business investigating the early creative activity of a transcendent God. Such a law is unenforceable, he contended, since human reason runs into all sorts of nooks and crannies quite incorrigibly. It can even scratch the surface of Chaos.

This Chaos resembles the prime matter, or formless matter, of much earlier philosophers, being something without being anything in particular. But it plays a more dignified role in cosmic development: it is God and Chaos that make up the world. God is

125

One-ness, Chaos is many-ness, and the twain met in the creation of order, an act into which God was spurred by Chaos (perhaps as a messy kitchen sink spurs a Dutch housewife).

That creation, however, was only the beginning. Divine creation is a perpetual process, arising not out of some sort of irreformable divine plan, but rather out of *ad hoc* divine reactions to the inertial resistances put up by Chaos against divine interference. Indeed, Chaos is full of surprises for God as well as for us. It keeps God on his toes.

With this impish potentiality for surprises, for unpredictability, Chaos is always threatening to get out of hand—*almost*. It cannot do so entirely, since God ultimately will always have the final say. Its lack of cooperation, however, accounts for the existence of evil in the world, against which a busy God is perpetually fighting a precariously winning battle.

Under such circumstances, God and the world are by no means one and the same. Nevertheless, Ehrenfels could not think of God as entirely "other." In a concession to pantheism, especially of the Oriental variety, he proposed that all the psychical entities in the world are somehow "partly identical" with God, emanating from God and returning to him in death, "very possibly" in a process like the transmigration of souls.

On another important aspect of this dualistic theism Ehrenfels displayed a proselytizing enthusiasm worthy of a used-car salesman in a sluggish market. To those doomed to suffering by an unkind fate, he noted, Christianity offers, apparently contrary to reason, indescribable comfort in its teaching that such worldly sorrows, if borne in submission to the will of God, will be more than made up for in the world to come. Does dualism, he asked rather competitively, offer any such comfort? Yes indeed, he shot back. As God advances into the unknown areas of Chaos, he anticipates the conflict and the suffering it brings to him as well as to his creatures. As he meets this suffering with unwavering courage, so must the human sufferer. "If you endure your pain without flinching—aware of your unity with God and, despite your suffering, affirmative toward the world and your whole life—you will grow in strength. God's own bold courage will strengthen you, and you will possess your share in the future wonders of life in this world."

For all his enthusiasm, Ehrenfels failed to explain why this promise is any less "apparently contrary to reason" than that of Christianity. Nor did he offer much reason to place one's confidence so completely in a brave but finite God possibly struggling to keep his head above water. But then psychologically, as the history of man so amply demonstrates, a finite God has a lot more to offer than no God at all.

The Space-Time Condominium

The early twentieth century saw the rise of the space-time continuum as a fashionable gambit at cosmological teas. An Australian-born British philosopher, Samuel Alexander (1856–1938), became so enamored of the idea that he used it as easel, canvas, palette and paint for his portrait of God. The portrait itself proved rather surrealistic.

Alexander was tempted simply to identify God with Space-Time. But such a God, however intellectually stimulating, could hardly be expected to evoke the emotional responses associated with worship, and Alexander decided that "a philosophy which left one portion of human experience suspended without attachment to the world of truth is gravely open to suspicion." To make up for this deficiency, he added a "quality of deity," which he wistfully identified as the quality just beyond (higher than) the highest quality we know ("mind") on the scale of evolutionary development. (Darwinian evolutionary theory also was being served liberally at cosmological teas.) Although it is beyond our ken, we know it is there by extrapolation, by analogy.

Thus "God is the whole world as possessing the quality of deity." This God, however, is not the actual God but is rather the ideal, the speculative God. The actual God is a good deal less imposing, consisting of the world plus an unceasing impetus toward divine fulfillment, always approaching but never arriving, forever becoming but never fully *being*. Nevertheless, this actual God is physically unlimited, "is the infinite world"; it is only the quality of deity, of "mind," that he can never fully possess. As for the form he might assume, "we cannot know, and it is idle to guess."

What we do know is that his experience is exclusively internal, unlike ours (excepting perhaps our kinesthesia), since he comprises the whole world. Thus our sensations and thoughts, our pleasure and pain, our very selves are all part of his experience. We "are the hunger and thirst, the heartbeats and the sweat of God. This is what Rabbi Ben Ezra says in Browning's poem, when he protests that he has never mistaken his end, to slake God's thirst." What Browning meant, perhaps only Alexander's God can know.

Such a description of God, as Alexander himself points out, "is full of figurative language." His fondness for analogy cropped up continually, as in his ready explanation of the "internal infinity" of the human mind. "An inch is internally infinite in respect of the number of its parts and corresponds to an infinite line of which it forms only a part. But it itself is finite in length. In the same way our minds, though finite in space-time, may be infinite in respect of their correspondence with the whole of things in Space-Time." (The initial capitals, and lack thereof, are his.)

Analogy is satisfying more often to writer than to reader. Assertions like "God's deity is lodged in a portion of his body" may have been quite therapeutic for Alexander, but they hardly bring his portrait of God into sharper focus. Perhaps that portrait depends more than most on what the viewer brings to it.

The Father Fantastic

What Sigmund Freud had to say about God arose quite logically from what he had to say about people. And perhaps psychologically from what, in his childhood, his resolutely Roman Catholic nanny had felt impelled to say about God.

Freud the disenchanted adult (1856–1939) was much bemused by the nearly universal appeal of religion. The reasons for this appeal, he decided, can be found in religion's effusive response to three universal human needs. It offers colorful information on how the world began, thus more or less satisfying a common, if undemanding, curiosity. It holds out some hope of protection against the troubles of this life and some consolation in the prospective joys of another. And it provides moral guidance for thought, word and deed along the difficult and puzzling passage from birth to death. Nothing else does all these things. Science may compete with some information about the world but not in providing any hope or moral guidance.

And so forlorn humanity has resorted to its talent for fantasizing. In a kind of low-grade but mass hallucination, it has inflated its individual human fathers into an idealized figure of fantastic power, intelligence, and authority. The creator of the family, of *me*, has thus been exaggerated into the Creator of the world. "The religious man's view of the world's creation is the same as that of his own."

As the child's existence comes from the father (and mother, Freud sometimes conceded), so does its sense of security. The paternal (parental?) power protected, or even rescued, the child from hunger, from the dark, from falling, from the unpleasant

vicissitudes of life to which it was so vulnerable. But this vulnerability, though lessened, by no means ends for the adult. He (she) still feels insecure, still weak and basically defenseless against the world, with its overwhelming slings and arrows of outrageous fortune. He can't bring himself to forego the protection that his father afforded, yet he has long recognized that his father's powers and attributes are as severely limited as his own. (Freud himself, as a boy, was shocked to learn one day that his father had been intimidated by a Neanderthal Aryan bully into stepping off the sidewalk, and had offered no resistance.) In his distress the adult therefore revives the potent father-figure of his early childhood, inflates it unconscionably, and seeks in it the answer to his need for consolation and protection. In short, he believes in God.

And so it was with the parental role of laying down the law. The child was instructed in acceptable and (more assiduously) against unacceptable behavior, the latter being associated with the threat or infliction of highly unpleasant consequences. Through a process of affectionate rewards and less friendly punishments, he was taught the kind of behavior that would earn him acceptance in the family and in society. When the child becomes an adult, he still needs an external source of such instruction, even though it be merely a reflection of his own conditioned responses. The parental commandments are written on the tablets of his heart, tablets that he can readily externalize. His Creator-Consoler-Protector thus becomes the Law-Giver, governing the world by means of a similar system of rewards and punishments, demanding adherence to his moral precepts as the price for acceptance, soliciting love for God as the price of security in the love of God. Even the supplication characteristic of the child-parent relationship is included, in the form of prayer, which permits some channeling of divine power and even some small share in it.

A small share in nothing, that is. For the power is no less an illusion than the God supposed to possess it. What is real in this world, in the world we know at first hand, is evil — the pain and other suffering from which there is no escape except by chance, and the vicious moral evil spread by mankind's innate talent for aggressive, destructive, even personally cruel behavior. Here again that other human talent, for fantasy, has come into play, offering

the devil as scapegoat. Just another illusion, Freud asserted, for the actual source of such evil is simply the human heart.

In this respect, and perhaps in an ironic sense, he may have implicitly agreed with Jesus Christ that the overweening love of self is the root of all evil, although he might not have honored the copyright.

The Dipolar Superentity

At about the time that Freud's critical attention was beginning to turn occasionally from couch to altar, an English mathematician named Alfred North Whitehead (1861–1947) was collaborating with Bertrand Russell (1872–1970) in the preparation of their monumental *Principia Mathematica*. Although on principles mathematical the two men worked in close agreement, they held radically different views on matters philosophical. It may be a comment on celebrated thinkers generally that these two, although always good friends, were so disdainful of each other's opinions: Whitehead thought Russell's were downright simplistic, and Russell thought Whitehead's were thoroughly confused.

Certainly Whitehead's word-portrait of God is complicated enough, and metaphorical enough, to confuse and irritate a flagging reader struggling through his heavily laden prose. An explanatory sentence on "the doctrine of objective immortality," for instance, runs thus: "Throughout the perishing occasions in the life of each temporal Creature, the inward source of distaste or of refreshment, the judge arising out of the very nature of things, redeemer or goddess of mischief, is the transformation of Itself, in the everlasting Being of God." The reader for whom this cheery assertion is crystal clear, and who has not yet sampled Whitehead, obviously has a treat in store.

He will find in Whitehead, according to some very reputable commentators, a major contribution to our human understanding of God. The mathematician-philosopher did have the courage to tackle the stubborn problem of reconciling a single, eternal, transcendent, absolute, changeless God with a humanoid God

133

intimately involved in a world that comprises a vast number of actual entities busily engaged in ceaseless change. Every entity, Whitehead proposed, has two sides to it (or him or her), a conceptual and a physical aspect (an idea bordering on the panpsychism that assigns mind and body to every object). The conceptual aspect includes a "subjective aim" that motivates and guides the entity as it progresses to its final end. The ultimate source of all such aims is the conceptual aspect of a unique, all-permeating entity, called God.

This God is thus the source, not of the universe (which coexists with him), but of its harmony and value. Like other entities, he has two aspects. He is a "dipolar" God (the term is Whitehead's, though not exclusively), being both "primordial" (conceptual) and "consequent" (physical). Dipolarity is not dualism: these are two aspects of only one Deity. In his primordial role God is "the unlimited conceptual realization of the absolute wealth of potentiality," existing eternally with the world, possessing an infinite comprehension of its immeasurable possibilities. In his consequent role God is the "conscious...realization of the actual world in the unity of his nature, and through the transformation of his wisdom."

Such a God is not a static, impassive God. His primordial nature may seem inactive, but his consequent nature is thoroughly dynamic, constantly interacting with everything in his universe, forever bringing divinity to fulfillment, in a sense always moving forward, "consequent upon the creative advance of the world." God and the world are interdependent, somewhat as the sculptor and his block of stone are interdependent. This is not to say they are equal in value, but rather that neither can do without the other if there is any progress to be made. In bringing his primordial concepts into realization, God "is the poet of the world, with tender patience leading it by his vision of truth, beauty, and goodness."

As a poet, God moves others by persuasion, and this implies a freedom in those persuaded—or not persuaded. This freedom in turn implies the existence of an element of disharmony, of evil. But that element, which never predominates, is engaged in a forever losing battle. God is infinitely capable of absorbing the aberrant experience.

Although this God sounds like a personal God, Whitehead was neither detailed nor very clear about what he believed in this respect. Certainly he ascribed personal characteristics to God — it's hard to conceive of an impersonal poet — yet he seemed reluctant to depict God as anything like the popular superman of Western institutional religions. He seems, indeed, to have been ambivalent about organized religion generally. Although he admired it at times as an "instrument of progress," he could also display some bitterness toward it on other occasions, as when he called it "the last refuge of human savagery."

Personal or not, he felt that the God he portrayed gives us a glimpse of "the origin of that drive toward limited ideals of perfection which haunts the Universe." The idea of a God may be beyond description, beyond imagination, beyond conception. But all our notions of right as against wrong, of achievement as against failure, require this foundation. "Otherwise every activity is merely a passing whiff of insignificance."

Whitehead's idea of divine dipolarity, partly foreshadowed by Samuel Alexander's "becoming" God, has produced some remarkably durable reverberations. It can be heard as an undercurrent in Nikolai Berdyaev's combination of an impassively absolute Trinity and a dynamically active Creator, in Martin Buber's dependent Deity, in Alan Watts' God who can "other" himself (all included in the pages that follow). And it gave rise to the "process" theology which, under the impetus provided by the American philosopher Charles Hartshorne and a few others, has become a major influence in late–twentieth-century portraits of God.

Process theologians, like other theologians crammed together into procrustean pigeonholes by eager classification freaks, are far from being homogenized. They do seem united, however, in accepting reason as well as revelation as a source of information, or as a method of obtaining it. They also show some consensus on the two aspects of God as eternal, absolute Being and as changeable, relative Becoming. Like Whitehead, they have bravely confronted the knotty paradox of timeless timeliness in the strenuous activity of an essentially inactive God. How successful they have been in handling the paradox is debatable, and is certainly being debated. But at least they know that ignoring it will not make it go away.

The Tragic Actor

The idea of a world created out of nothing may have been unacceptable to Whitehead, but Nikolai Berdyaev (1874–1948) found it irresistible. The Russian expatriate philosopher may indeed be history's most ardent admirer of Nothing. He used it quite imaginatively to explain the existence of evil in a world created by a God of sacrificial love, whom he admired even more fervently. In his devotion to the triune Christian God he seems almost to stand among modern philosophers as an Alyosha among the brothers Karamazov.

He was impatient with "the conventional theology that leads honest men, with good motives, to atheism" because of its failure to account satisfactorily for the obtrusive presence of evil in a world governed by divine providence. The reason for this failure, he proposed, is the unfounded assumption that the Creator is prior to evil and thus responsible for it. But the truth is quite different. The Holy Trinity is the Divine Nothing. (By the Nothing he may have meant simply the totally indefinable; his nomenclature seems to have come from the foggy bottoms of German mysticism.) This Nothing, preceding all existence, generated the Father-Creator of the universe. Freedom, with its eternal roots in the Nothing, is prior to creation and the Creator. But freedom necessarily entails the existence of evil; if it excluded evil totally in favor of undiluted good, it would be predetermination, not freedom. Thus the Creator, who did not introduce freedom into the world, cannot be held accountable for the evil that accompanies it.

Although some unfounded assumptions may be seen lurking in the darker recesses of this argument, Berdyaev cannot be justly

faulted for not trying. Part of his dauntless effort went into his concept of freedom, which he called "meonic," from a Greek word for "nothing," to indicate its source. With the creation of a world comes a creation of values, which can involve some conflict — the clash between two beautiful but inharmonious colors, between a mother's love for her child and her love for her husband, between justice and mercy, and so on. Such conflict is a restriction of freedom and a source of evil, which is therefore unavoidable if there's to be any world at all. "The Creator has power over everything created but not over the Nothing, or over uncreated freedom, which he cannot penetrate. In the initial creative act God is seen as the world's maker, but the act could not avoid the potentiality of evil included in meonic freedom. The myth of the fall of man reveals the Creator's inability to prevent the evil arising out of the freedom that he did not create."

The basic conflict involved here gave Berdyaev an opportunity to depict the drama of God in two acts. In the first act the Trinity arises out of the abyssal Divine Nothing and begets the Creator, who makes the world and mankind out of nothing only to meet with a defiant animosity — a perfectly plausible outcome under the rule of freedom. This negative reaction is a denial of reality, a reversion to the original "nothing," which in this instance now turns to evil. In the second act God enters into this evil pit to expunge the evil through a divine sacrifice, purging freedom but not destroying it.

This effort to clarify the Christian Incarnation rests on a concept of God at least as dipolar as Whitehead's. It offers (1) the Trinity as the infinite, eternal, unchanging Absolute and (2) the self-sacrificing Creator as the dynamically active God thoroughly involved in his creation. Since "sacrifice always implies tragedy," this God is the supreme tragic actor on the world stage, engaged everlastingly in a divine mystery play, a suffering victim struggling toward ultimate victory.

And a very personal God of boundless love. Berdyaev could not stomach the God of the Old Testament, whom he considered self-centered, self-satisfied, haughtily self-sufficient, adamantly unmoveable, and unbearably demanding. The redeeming God of Christianity, he felt, is no such Mr. Barrett of Wimpole Street but

is rather a source of selfless compassion. It is this which makes him a Person. Furthermore, for Beryaev no person can exist alone, even at the divine level, but must have another to relate to. This is why a solitary Absolute could not be a Person—and why the divine Persons are three, bound together in mutual love and understanding. And, finally, why God can relate, also in mutual love and understanding, with the persons of his creation.

Berdyaev may himself have been philosophically dipolar, an incongruous mixture of Marxism and Christian mysticism. He believed that truth is reached not by reason but by "a light that shines through from the transcendent spiritual world." We will have to take his word for it.

The Ideal Incentive

Nothing could offer much sharper contrast to Berdyaev's wistful Russian mysticism than John Dewey's American know-how pragmatism. The human animal, Dewey (1859–1952) maintained, is a problem-solver with a plateful of pressing problems, and the worth of a philosophy, or anything else, is to be judged by how much it helps in solving those problems.

Theism he therefore dismissed as worthless. Indeed, worse than worthless, since a philosophy based on a belief in a personal, active God encourages people to wait passively for their problems to be solved by Somebody Else; it drains them of the gumption, the self-reliance, that a real crackerjack problem-solver must have. What *will* help them, in contrast, is the scientific method of inquiry, of hypothesis and experiment — "the method," Dewey called it, "by which truth is obtained." Looking forward to pie in the sky can never be as useful as popping a pie into the oven.

Although Dewey had very little to say about the God he did not believe in, some respectful attention must be given to even a sketchy portrait by a thinker who had such a mighty impact on American education and philosophy in the first half of the twentieth century, and who, in the citation accompanying the honorary degree he received from the University of Paris in 1930, was saluted as "the most profound, the most complete expression of the American genius." His negative attitude toward any belief in a personal God doubtless was partly a reaction against another kind of American genius, the fanatic and incorrigible fundamentalist such as William Jennings Bryan displayed himself to be in the mid-1920's in the widely publicized "monkey trial" of John Scopes.

He seems also to have reacted similarly to all varieties of idealism, from Plato to Plotinus to Hegel to Berdyaev. Reality falls so short of our ideals, he asserted, that we natually want to think that the ideals actually exist — out there, up there, somewhere. "Desire has a powerful influence upon intellectual beliefs."

Intellectual beliefs in the existence of anything supernatural can be explained in terms of human desire or fear. In mankind's early history, or prehistory, fear was the more influential of the two, but the burgeoning competence of science and technology has tipped the scales. "Primitive man was so impotent [that] fear became a dominant attitude, and, as the old saying goes, fear created the gods. With increase of mechanisms of control, the element of fear has, relatively speaking, subsided." As the fear has subsided, we have grown more able to think dispassionately about the world and thereby to recognize that the notion of a personal, all-powerful God is not the product of a detached, scientific investigation; that it has arisen chiefly if not entirely out of mystical experiences which can be understood quite satisfactorily as natural, neurological phenomena; and that it collapses under the weight of "all the problems of the existence of evil that have haunted theology in the past and that the most ingenious apologetics have not faced, much less met." The failure to account for evil and the frequent refusals even to acknowledge its existence are especially frustrating, since we are all intimately aware "that there are in life all sorts of things that are evil to us because we would have them otherwise."

We strive to make them otherwise, or at least more otherwise than they are. The incentive behind our efforts comes from the ideals that we envision. It is easy enough when we are in poor health, for instance, to imagine the perfect health we would like to be enjoying, and this ideal gives us some motivation for doing something about it. In this context Dewey was guardedly willing to accept the term "God" when "it denotes the unity of all ideal ends arousing us to desire and action" — or, to put it more elaborately, when it "means the ideal ends that at a given time and place one acknowledges as having authority over his volition and emotion, the values to which one is supremely devoted, as far as these ends, through imagination, take on unity." Thus "God" can be

considered a kind of Ideal Incentive, very persuasive but quite impersonal and indeed nonexistent outside the human mind. This is enough, "since all that Existence can add is force to establish, to punish, and to reward."

The ideals, though not actually existing, have their roots in existing, observable reality and are "unified by the action that gives them coherence and solidity. It is this *active* relation between ideal and actual to which I would give the name 'God.'" Evidently Dewey fully agreed with what Juliet had to say about the rose.

The Omega Point

Although Dewey was a resolute agnostic, he shared the notion of a central incentive, quite fortuitously, with the maverick Jesuit mystic and fervent believer, Pierre Teilhard de Chardin (1881–1955). Teilhard also shared in Dewey's apotheosis of the methods and achievements of science. He was a paleontologist and anthropologist of no small repute, having played an important part in the discovery of the Peking man. From his experience in these disciplines he developed a philosophy of reconciliation between the beliefs in God and in the evolution of the world and mankind.

Against the widespread acceptance of evolution as a repudiation of God, Teilhard argued that the evolutionary process has an observable direction, with God as goal and impetus. The data of paleontology reveal a line of irreversible development, of increasingly organized energy rising from totally inert matter through atomic and molecular structure, primitive protoplasmic organism, plants, animals, and humanity. It is true, he conceded, that we can detect quite an opposite trend in matter on the purely physical level, a creeping entropy in which energy is winding down, becoming ever more disorganized and diffuse. But on the psychical level we can observe the progression of harmonious complexity in the growth of intelligent consciousness, which took a quantum leap with the advent of the human species, the only species that not only can know but also can know that it knows.

This inexorable progression, on closer inspection, turns out to be a convergence, with the world of reflective consciousness narrowing in scope, as it were, while increasing in intensity. Like any

other convergence, it must be headed toward some single point, whether that point is clearly identifiable or not. In this context, the convergence must lead to an ineffable ultimate in consciousness, which Teilhard calls the Omega Point. While the rest of the universe may eventually succumb to entropy, cravenly decaying into a featureless soup, the psychical element is clearly en route to union with Omega at the point where the One will embrace all multiplicity, welcoming the human spirit to its final destiny and completing the mystery of the divine Incarnation.

Something must account for this movement of the spirit toward its goal. Since no significant force could be exerted from behind, where things are so much less lively, the only alternative is an attractive force exerted by the goal itself, Omega. The movement of the spirit, being essentially an intensification of personality, must be attracted toward the ultimate in personality. The foremost virtue of personality is love, which thus must be the overriding power drawing the world of the human spirit together into an all-engulfing vortex, where human love will find its center, and its quintessence, in the divine milieu. This is the communion of saints in what St. Paul called the mystical body of the divine Christ — the Omega-Christ who fills and coordinates and animates the world, the Word Incarnate that guides and quickens the evolution of human spirituality in the divine light of the Holy Spirit, the ever present, ever beckoning paragon at the apex of universal love.

Science, far from denying this view of the world, provides the data with which religion can develop it. Science and religion are simply two facets of human knowledge leading to an awareness of a final destiny. For Teilhard, the God of Religion — especially of Christianity and most especially of Roman Catholicism — is the God of science as well.

The Encompassing Thou

Dewey's rigorously impersonal God obviously lacks the charisma demanded by most of the human race. A much different and, for many, a much more appealing portrait was offered in the 1920s by Martin Buber (1878–1965), the Vienna-born Jewish philosopher who was later to flee from Nazi ogredom and settle in Israel, there to become a controversial seeker after peace in the Middle East (controversial because he had the gall to suggest some compromises).

To thinkers like Dewey he responded that brow-furrowing investigations into the fleeting reality that we observe in this life simply lead to the incomprehensible. To idealists he responded that airy dismissals of such reality simply lead into the void. But those who wish to sanctify this life will encounter "the living God" because they think of God as a vital, personal "*Thou*" in a spirit of mutual love, rather than as an "*It*" to be weighed in a scale of human values and be found wanting. God is not an *It*, he insisted, like something observed under a microscope or like a person being surveyed in a statistical study. Nor is he like something inferred from the behavior of other things observed. The all-encompassing God is not to be inferred. In the *I-Thou*, the human-divine relationship, he is much too close for that. He is closer to me than I.

The relationship is one of interdependence. We are directly and acutely aware of our dependence on God, but we know too that he must need us, or else why would we exist? God is what our lives are all about. In this relationship with his creatures, the changeless God somehow embraces change as "we participate in

144

creation," and he thereby acknowledges his dependence — as he does more explicitly in the scriptures and liturgies of all religions, demanding concrete evidence of our devotion and loyalty.

This is why God can respond to prayer and sacrifice — which treat God as *Thou* and thus differ essentially from magic, which treats God as *It*. The "praying man who pours out his soul in a spirit of total dependence is confident that, incomprehensibly, he is having an effect on God, although he receives nothing." Indeed, it is when he stops wanting something for himself that he perceives the greatest effect.

The scriptures and liturgies of the world's diverse religions offer various portraits of God, each more or less further transformed in the eye of each beholder. Buber's portrait is almost as spare as Dewey's because he accepted this process of individual transformation: he felt that each individual portrait, even though radically touched up, is valid for its particular beholder. For Buber, the relationship is paramount. Philosophers who ignore this relationship, or who try to extricate themselves from it in order to objectify and examine the mysterious *It*, are engaged, however blithely, in a futile exercise. The *It* is unfathomable, but "each individual *Thou* is a glimpse into the eternal *Thou*."

In his view, this personal glimpse, this contemplative intuition, is really all that matters. We should be seeking union, not asking for credentials.

The Crucial Dilemma

If the viewpoints of Berdyaev, Dewey and Buber could be combined, perhaps the uneasy combination would be discernible in the profound misgivings and stalwart faith of Albert Schweitzer (1875–1965), whose work as a medical missionary in equatorial Africa earned him the admiration of humanitarians all over the world—and enough fame for him to be included in a Nichols and May comedy sketch.

All religious difficulties, Schweitzer observed, ultimately revert to the difference between what we know of God from personal, internal experience and what we know of him from our contemplation of the world. The internal God is an ethically motivating Will; the external God is a wonderful, mysterious creative Power. The internal God is personal, while the external God is thoroughly impersonal. Thus the God of personal experience and the God of speculative philosophy, whatever their superficial resemblances, are as different as the crying of a child and the moaning of the wind. How these two can be one God, the same God, surpasses all human understanding.

Of the two, the personal God is the more intimately, and thereby the more fully and more surely, known. My knowledge of the impersonal God is indirect and incomplete, coming as it does from observing things outside myself. Although I can watch a plant grow, filling itself out with leaves and flowers, I cannot grasp the power behind the mysterious process. But I know of the personal God from things going on within me, which directly reveal the universal creative power as inspiring my own creative urges,

an ethical Will within me urging me on, impelling me to sublimate my life.

In an effort to reconcile these two incompatible deities, Schweitzer not surprisingly resorted to analogy, to mystical metaphor. Consider the Atlantic Ocean, he suggested. Just as this great, cold body of water contains the Gulf Stream, a warm current moving from southern climes to northern, so the God of love, warm and personal, moves within the cold God of creative power, the two being intimately united yet quite different. As with most such metaphors, the value of this one doubtless relies heavily on the eye of the beholder.

Its value for Schweitzer arose partly out of his conviction that "profound religion is mystical." What we most ardently yearn for is release from this world through union with God, not through an arid intellectual union such as that envisioned in Eastern religions but rather through the "ethical mysticism" of Christianity. Here alone shall we find a truly vital spirituality, a genuine release from the material world. What is really important, therefore, is not how much we know or don't know about God but how thoroughly we commit ourselves to him.

Schweitzer spectacularly exemplified the age-old conflict between faith and reason. As one of his biographers (Werner Picht) put it, in Schweitzer's theology God doesn't occupy a very important position. Philosophically Schweitzer was an agnostic, yet he spent his life in the service of a God that he could never quite discern, committed by his fervent faith in a God of infinite love.

His only absolute, if any, seems to have been his respect for life, life of any kind, carried to such extremes that it troubled him, as a veterinarian, to save the life of a predator or, as a doctor, to restore human health by destroying bacteria. Therefore the problem of evil—"nature red in tooth and claw," among other things—must have disturbed him profoundly. Although he does not seem to have treated it explicitly, or philosophically, he made a pregnant comment on it obliquely in his *Notes from Lambaréné*. In reporting on moving the mission's patients into a new hospital, he wrote, "For the first time in my African work the patients have shelter worthy of human beings. Oh, how I suffered during the years

when I had to corral them in dark and stifling rooms! Filled with gratitude I look up to God, who has permitted me to know such happiness." This says a good deal about the problem of evil, as well as about Albert Schweitzer.

The Even Higher Above

Albert Schweitzer may have capitulated in the conflict between faith and reason, but Paul Tillich (1886–1965), was not about to be so readily intimidated. This German-American philosopher and "apostle to the skeptics," though aware that the traditional reconciliation by Aquinas had grown unfashionable since its airy dismissal by Kant, was determined to have another go at it.

In doing so, however, he turned from Aristotle and Aquinas to Plato and Augustine, postulating a human "awareness" of the Absolute as the source of faith. This is a direct, immediate consciousness, replete with utter certainty. Doubt enters the picture only in the effort to specify the object of faith. This effort, since it relies on fallible human reason and resorts to the use of handy symbols like Zeus and Jehovah to represent the indiscernible Ultimate, necessarily involves a measure of uncertainty. We can live with such uncertainty about the symbols, as indeed we must — but, with Kierkegaard, we nervously demand more from our faith in the One above the symbols. And we can expect more because this One is not a mere object of our intelligence but is rather the ground of all being, what Tillich called "being-itself." This is the only nonsymbolic assertion that can be made about God.

Since the approach of Aquinas & Co. offers nothing more than arguments for the probable existence of a symbol, Tillich projected a God "above" the God of conventional theism, the God of "being-itself" that provides the "content" of our absolute faith. Faith and reason do not conflict because the "object" of reason is distinct from the "content" of faith. Reason presupposes faith, and faith fulfills reason. Faith is "reason in ecstasy." What could be simpler?

Nevertheless, amid all this harmony, there is some conceptual conflict between the supreme God of faith and the lesser, symbolic Gods of reason. Tillich was not disdainful of the latter; he considered them a necessary response to the human demand for the concrete in divinity, in addition to the ultimate. He saw polytheism as emphasizing the concrete, monotheism as emphasizing the ultimate, and pantheism as negating the concrete in favor of an unacceptably omnivorous ultimate. Only in trinitarian monotheism, he maintained, could the conflict be adequately resolved in a balance between the two requirements. And a trinitarian monotheism is, of course, conveniently at hand.

This opinion led to an acceptance of divine revelation, and particularly of the Christian revelation, which Tillich considered not only to be the last word but, further, to be the standard for judging all other revelations. Jesus Christ, in his view, is uniquely in union with "the God above God," thereby giving meaning to every human life and to human history. And so Tillich, thus fortified by revelation, was able to ascribe some attributes to God in symbolic, or metaphorical, terms.

God is personal, for instance, but only in the sense that he is "not less than personal." Atheists are quite correct in denying the personal God of conventional atheism, whose existence no evidence supports and who is of no ultimate consequence anyway. God possesses "the ontological power of personality" which, without shrinking him to human dimensions, permits a personal relationship with his creatures.

Such a relationship is possible through God's spirituality, which is "the most embracing, direct, and unrestricted symbol for the divine life." The divine Spirit, as the fulfillment of life, manifests itself in the salvation of the human spirit, relating the infinite to the finite through a mystical union with the Trinity. Similarly, the infinite God somehow freely transcends the finite world yet infuses it with the "being-itself" without which it simply could not be. And again, God, or the "divine eternity," both transcends time and includes it, permitting movement from the past into the future within an "eternal present" and enabling humanity to share in the eternal life of the Divinity.

This divine participation in the world mystically allows for the

notion of divine providence, not as some sort of outside interference but rather as "a quality of inner directedness in every situation." Providence in this sense can be held accountable not for particular events or conditions (which can be evil) but only for the general direction of all things toward their fulfillment. Thus someone with a belief in divine providence will be confident that "no situation whatever can frustrate the fulfillment of his ultimate destiny, that nothing can separate him from the love of God which is in Jesus Christ (Romans, chapter 8)." (Tillich's reliance on St. Paul's epistle doubtless is highly significant.) In this divine providence can be seen the divine justice and love described so graphically in the Christian revelation. The justice of "the Lord" is united with the love of "our Father" in a divine response to the alienation of the human spirit.

Thinkers in the tradition of John Dewey, if not of Aristotle and Aquinas, must look upon Tillich's bridge between faith and reason as a precarious span of impalpable gossamer. But for many others of more mystical bent that bridge, however seemingly insubstantial, has borne great burdens of human anxiety — and somehow, in the process, often lightened them.

The Fortress Revisited

Luther's abusive rejection of human reason as a pathway to God faded with time into such attitudes as Kierkegaard's preference for a "leap of faith" and Schweitzer's preference for, essentially, not thinking about it at all. But after the traumatic experience of the first World War, a voice could be heard calling across Europe's battered landscape for a return to Luther's choice of pathways, if not his choice of words.

Although his words were not so pungent, the Swiss theologian Karl Barth (1886–1968) did not believe in mincing them. Any "natural" knowledge of God, he vigorously asserted, raises such a cloud of doubt and anxiety that it cannot but lead to a false portrait of God. Only the Word, the Christian revelation, can bring the absolute certitude needed for obedience to God's law. Only the Word can give us any reliable information on whether God exists, what his attributes are, what his relationship with us is, and so on. The Word can give rise to doubt and anxiety, Barth conceded, but like Luther he felt that reason *after* faith could be used legitimately and effectively to eliminate any uncertainty. Reason can never be more than a self-effacing handmaiden to the human intuition of God that comes through the Holy Spirit, the light of holy scripture. That intuition constitutes our faith, our affirmative response to God's will.

This God is the mystery, the "hidden" God known only to himself, a God of incomprehensible might inspiring fear in human hearts. But it is also a God whose clear message of overwhelming love brings peace and security to those same hearts. The love is overwhelming indeed: in Barth's world, unlike Calvin's, all human

152

beings are predestined for eternal salvation through the self-sacrificing love of Jesus Christ, the divine Son. As our stand-in, Christ accepted the punishment that we deserved. And so, in Barth's optimistic view, we are all headed for the kingdom. Even an atheist, as he saw it, displays a redeeming faith in his very denials. Christ's resurrection represents God's affirmative response to *us*.

Thus the Christian Trinity is of paramount importance in Barth's theology. The three Persons, however, seem to be aspects of God revealed in scripture rather than metaphysically separate persons. The Father is the revealer of truth, the Son is the truth revealed, and the Holy Spirit is the act of revelation. In our acceptance of that revelation we receive the divine grace that stretches across the abyss yawning between God and mankind. But for the grace, that black abyss would remain forever unbridgeable.

The Lately Departed

In 1961 Gabriel Vahanian, an American disciple of Karl Barth, published his *The Death of God*. With this title he christened a ship of state of mind that sailed through the sixties with a crew of mostly American, mostly young theological salts bent on casting the Skipper overboard.

The Nietzschean phrase covered a multitude of viewpoints too diverse for the trend to be called a movement, or perhaps even a trend. This whatever-it-was doubtless had some roots in the thought of Barth's rival, Rudolph Bultmann, who among other things had absorbed Schweitzer's doubts about the historical Jesus and converted them into a conviction that Jesus had never lived anywhere outside some overripe imaginations in the myth-making industry. The work of Dietrich Bonhoeffer, much of it written amid the miseries of a German prison camp during World War II, became popular with its suggestion that the God of institutional religion, if not dead, was at least suffering from terminal irrelevance. Barth himself probably contributed a great deal with his hacking away at the rational underpinnings of a Christian faith.

During the lifetime of God's death a number of contributions appeared in Vahanian's wake, notably Harvey Cox's *The Secular City*, Thomas J. J. Altizer's *The Gospel of Christian Atheism*, William Hamilton's *The New Essence of Christianity*, and Paul M. van Buren's *The Secular Meaning of the Gospel*. Since Van Buren seems to have conducted the most radical of these autopsies, his viewpoint may be the most interesting. Although extreme, his outlook is by no means unrepresentative; it isn't so much a point of departure as a

point of convergence. After all, he earned his doctorate in theology under none other than Karl Barth.

Like Barth and Luther before him, he has displayed considerable impatience with the piecemeal dismantling of the Biblical God being carried out by various technicians engaged in the perennial effort to reconcile the three busy Persons with the imperturbable, ineffable One. The portrait of the One which caters to all criticisms, he has complained, will wind up a blank canvas. In this connection he tells a story, attributed to Anthony Flew and John Wisdom, about a couple of explorers who happen upon a garden in the middle of a jungle. They argue over whether it implies the existence of a gardener. To settle the argument they keep watch on the garden, but no gardener ever appears to tend it. Yet maybe he is invisible — so they ring the garden with a fence of electrified barb wire. (The story does not pretend to meticulous realism.) No sign of a gardener. They patrol the area with bloodhounds. No gardener. Yet the faithful explorer persists: there *must* be a gardener, undetectably caring for the garden because he loves it so. At this the sceptical explorer explodes with impatience: "Just how does what you call an invisible, intangible, eternally elusive gardener differ from an imaginary gardener or even from no gardener at all?"

Although the story fails to explain the symmetry of the garden or the claims of some people to have a message from the gardener, it does invite some understanding of the vexation that inspired it. The assertion that God is dead came not from any hostility toward God but rather from irritations with the logic-choppers who nibbled him to death. And also, on the other side of the line, from irritation with the fulsome portraits of actively solicitous Men Upstairs, which, like ancient Egyptian murals, represent a culture now diagnosed as irrevocably dead. On the positive side, this junking of divine portraits has created a need for providing mankind with a suitable replacement, and the theological undertakers as a group, inspired by the latest resurgence of humanism, seem to have come up with one: a looking glass.

The Multiple Unity

While Tillich was accommodating Western mysticism on America's East Coast, Alan Watts was accommodating Eastern mysticism on, appropriately, the West Coast. Like William James, Watts (1915–1973), as an apostle to the Beat Generation, showed considerable impatience with the cold intellectuality underlying most Western theologies. What is needed in Western portraits of God, he proposed, is more feeling. And the unfailing source of such inspirational feeling is the Orient.

Western portraits have shown God generally as quite separate from the world, even raising the historical figure of Jesus onto a towering pedestal, far above the common "sinners" with whom, during his life, he was constantly associated. This illusory exaltation has arisen out of the fear of contaminating the unity of God with the diversity of the many. It arises also out of a false notion of the divine unity, a predominantly Christian notion that can be corrected by aligning it with an Eastern notion that "God is That which has no opposite."

One must not think of God as a creature, identifiable in its distinction from other creatures. Creatures are limited by their opposites — this is not that, I am not you, and so on — but God has no opposites and therefore no limitations. Unlike any creature, God can "be what he is not"; he can "other" himself. And unlike Western ideas of God, particularly those in the tradition of Aquinas & Co., this concept allows for divine multiplicity and diversity, which constitute not "a privation" but rather "a perfection of being."

This idea combines the best features of both worlds. It

maintains the unity of God without denying the reality of the universe with all its teeming variety. It affirms the infinity of God without casting finite realities into the outer darkness of illusion. It acknowledges eternity without destroying time. Unlike the ascetic, Manichaean-tinged Christian theology of the early Middle Ages, but like the essential Christian doctrine of the Incarnation, it loves both God and the world. Indeed, only in God's embrace of our diversity can we ever be touched by his unity and feel his love.

In a God so much at one with the world we can recognize "the beauty which we perceive in nature and create in art." The Western emphasis on truth over beauty has been largely responsible for a widespread Christian sentimentality over such images as Bearded Father and Baby Jesus, reeking of a "maudlin emotionalism of prolonged adolescence." Piety of this sort, although it may involve feeling, does more to separate mankind from God than otherwise. In contrast, a genuine aesthetic appreciation of God, such as can be found in Eastern mysticism, promotes union with the beauty in God — attracting the beholder, as it were, with a gentle fragrance, rather than repelling him with "a crude perfume."

This appreciation will include a recognition of the feminine aspect of God. The all-powerful, aggressively male King of kings, too formidable to look upon, also has "the feminine qualities of cherishing love, self-effacement, compassion and graciousness" which have been rather disdainfully neglected in Christianity — or, in modern times, in Protestantism, since popular Catholicism has assigned such qualities largely to the ubiquitous Mother of God. This assignment has led to an uneasy compromise between a masculine God and a feminine Mother, thereby giving the faithful "the hermaphrodite Christ of popular Church art" — "solemn, effeminate, sanctimonious, moralizing, ethereal, neither red-bloodedly human nor majestically divine."

The therapy that Watts offered for this malaise, unfortunately, seems to be nothing more than right thinking, imprecisely defined. But he described the cure in glowing terms. A believer who is dissatisfied with such images, he wrote, "must go to that mystical center which is beyond all ordinary forms of symbolism and there

touch the Life which will, in due time, express itself in a nobler im-
age of God and enable him to see a more splendid Christ in the
pages of the Gospels." To cure dissatisfaction, after all, one need
only heal the eye of the beholder.

The Relative Absolute

A blend of Eastern mysticism and Western rationalism, laced with a generous dollop of Tillich and a dash of Watts, has come from the palette of Sarvepalli Radhakrishnan, the statesman and scholar whose career included roles as ambassador, United Nations delegate, and president of India. The cosmopolitan flavor of his career seems to have entered into his portrait of God.

The portrait reveals a triune God with very Western lineaments against a background of an Absolute with very Eastern intangibility. The Absolute is the very being of being, the essence of consciousness, freedom, unlimited potentiality and ceaseless activity. It is God, if you will, but God as abstracted totally from the world.

The Absolute is related to the world, however — and in this role is more commonly known as God — in a divine trinity: "as the primordial mind, the loving redeemer, and the holy judge of the universe," envisioned in Hindu theology as Brahma, Vishnu, and Siva. The mind of Brahma is something of a Platonic repository for the ideal forms toward which "all things yearn." But this mind is a creative mind, and its ideas are gradually transformed "into the plane of space-time" in a process advanced through the generative and communicative power of God. "God as Vishnu is sacrifice," dedicated to resisting every worldly penchant for the false, the ugly, the wicked in the unceasing battle between good and evil. This is the operation of divine love, which guarantees that the world cannot ever "tumble off into ruin." Nevertheless, since we can freely choose not to return that love nor to imitate it, the world (including God's participation in it) always involves some uncer-

tainty. "There is real indetermination, and God himself is in the make."

Thus, however unchanging and detached the Absolute may be, the God of involvement participates in change, in struggle, even in growth. He is "intensely interested" in the world's progress toward perfection along a path of human freedom. This interest expresses his love, which is more central to his nature than intelligence or power, a love that arises out of his "organic" unity with the universe.

Whatever may be thought of his solution, Radhakrishnan had a firm grasp of the problem: "The great problem of the philosophy of religion has been the reconciliation of the character of the Absolute as in a sense eternally complete with the character of God as a self-determining principle manifested in a temporal development which includes nature and man." Just how absolute can God be, and how can he be absolute in, or with, an unconscionably relative universe? Radhakrishnan seemed to acknowledge the intractability of the problem when he resorted to metaphor in writing about even his Absolute, which he described as "choosing" this world for creation from among countless possibilities and as exercising its (his? her?) "power of saying yes or no." He was walking a very slack tightrope that had frustrated many earlier balancing acts more celebrated than his own.

The God of Democracy

Attempts to reconcile competing notions of God can be exercises in self-delusion, but this possibility did not faze the redoubtable and intellectually versatile Paul Weiss. Although diffident in his presentation, this engaging American philosopher displayed a firm commitment in his view of "the problem of God and the world" (essentially as Radhakrishnan posed it).

This view, he proposed, showed that the various opinions of God from "theology, religion, ethics, philosophy and science" represent separate but reconcilable perspectives. The truth is generous enough to include traditional beliefs of the past along with the discoveries and theories of the future. It can recognize the scientific postulate of a real world regulated by uniform physical laws. It can appreciate Oriental perceptions of the mystical element in mankind's relationship with God. It can accept Plato's notion of a creative World Soul and Aristotle's self-contemplating Intellect, the Hebrews' God of severe anxiety and the Christians' God of loving peace, Spinoza's all-inclusive Reality and Whitehead's God of separation and involvement. It can harmonize God's infinite knowledge and power with the existence of evil, his timelessness with his involvement in a world of change, his justice with his compassion. One could hardly ask for a more commodious philosophy.

Our knowledge of God's existence, he argued, comes from our awareness of the endurance of our own individual identities amid ceaseless change. "I persist, therefore God exists." And the reverse also is true: the things of this world continue to exist because of God's dynamic existence. "God is the eternal memory to which all

natural things refer for a constant reference appropriate to their identities." Through his own self-awareness God understands the nature of each individual thing, since each thing "is nothing other than a part of God's infinite essence and being." He is the Platonic Form in one sense, the Aristotelian Understanding in another.

Thus the Creator doesn't produce things so much as he reproduces them from his essence. Or, more precisely (considering the source), he knows and reproduces "the goodness of things," things in harmony with themselves, the rest of nature, and eternal being. Evil consists of the failure to achieve "the status of an eternal being" through dissipating one's energy in satisfying fleeting desires. The interplay of the constant longings between the Creator and his creatures "constitutes that theological space in which the drama of the conquest of the evil by the good takes place." Theological space is where Creator and creatures unite to form one cosmos. It is also the space described by Milton, through which the defiant Satan was

> Hurled headlong flaming from the ethereal sky,
> With hideous ruin and combustion, down
> To bottomless perdition; there to dwell
> In adamantine chains and penal fire,
> Who durst defy the Omnipotent to arms.

In this sense Plato's World Soul and Spinoza's all-embracing Reality are simply two aspects of the same God who permeates and extends beyond theological space and who constitutes the ideal universal soul. A recognition of the complementary functions of these two notions permits us to avoid Spinoza's unbridled pantheism and Plato's limitations on divinity. It also paves the way for considering "the reports of genuine mystical experiences" which reach across theological space and acquaint us with divine perfection.

This acquaintance helps us understand that the "relation of God to nature is like that of the soul to the body." Just as we must strive to perfect the harmony between soul and body, so must God in his providence strive to perfect the harmony between himself and his creatures. If we recognize this, we will also recognize the

intrinsic value of his creatures, and this in turn will lead us to a knowledge and love of God.

A knowledge of God thus requires the methods of science, which is "not merely the best instrument for the understanding of the details of nature, but the most effective means of attaining the good" and is therefore a channel to God. Here we have the double faith of democracy: "the scientific faith in the existence of an independent, self-contained world of valuable things where a man comes to be, acts and dies without aid from without, and a religious faith in the existence of a God who is forever on the side of right." The egalitarian God of democracy needs his creatures as much as his creatures need him. Only through cooperation can a community of joy and perfection be achieved.

If the portrait that Weiss has painted is less than clear in many respects, at least it is recognizable and suitable for exhibit.

Afterword

In his human portraits God has ranged from Absolutely Everything to Absolutely Nothing. A spectrum any broader would be hard to find.

But then trying to paint portraits of God is something like trying to paint portraits of Beethoven from his music alone. Such portraits could be interesting, appealing, formidable, inspiring, and in some ways (especially if it were Wagner rather than Beethoven) even revealing, but how could they be photographically accurate? The variety of portrayal surely would be staggering, such as we can see in the recorded opinions of critics and interpreters past and present. Genius and divinity, like beauty, can be merely glints in the eyes of the beholders. (Of *other* beholders, of course.)

Faith vs. *Reason*

Word portraits of God can be separated historically into two distinguishable if uncontrollably overlapping classes: those painted in the warm glow of intuition or faith, and those painted in the cooler light of reason. Though certainly not mutually exclusive, the two classes do have their representatives, from Plato and Augustine to Kierkegaard and Tillich, from Aristotle and Aquinas to James and Whitehead. As James obliquely suggested, vacillating between the two has been a perennially painful experience for thoughtful individuals and indeed for mankind in general.

The vacillations attest the basic dilemma: the active, personal

God of faith is emotionally satisfying but intellectually implausible, while the unchanging, unimaginable God of reason is intellectually tolerable but emotionally unattractive. Although every major religion has tried to meet both needs, the dilemma remains, a persistent echo of the ancient enigma of the invariable One behind the mercurial Many. Most religions have at least tolerated a hierarchy of godlings to meet popular demand for divine solicitude, some have introduced the notion of a divine incarnation, and a few have simply ignored the problem, positing a vaguely eternal but vividly humanoid God regardless of any logical consequences.

The "problem," which has survived all such ignorance, evidently arises out of a deep-seated human uneasiness with the notion of unlimited change. Mathematicians use an arbitrary "infinity" to spruce up their equations, of course, but this is as real as the classic proposition that no one can ever reach a destination because half the distance to it must be covered first, then half the remaining distance, then half the still remaining distance, and so on infinitely. The changes that we observe and read about, whether seen on the farm or through a radio telescope or in a cloud chamber, are clearly discrete events that occur one after another (star to supernova, hydrogen to helium), so that the number of them occurring in any microsecond, or in any century, must be limited, however enormous. If the series of changes had no beginning, then the total number of changes must *already* be unlimited, larger than the largest number conceivable. But this is both theoretically and practically impossible: theoretically because there is always $x + 1$, and practically because the number is constantly, irresistibly growing before our very eyes. So the series *must* have had a beginning, a conclusion that can be held about as confidently as your conclusion that you *must* have had 32 great-great-great-grandparents. Small wonder that so many human intellects have been unable to digest the notion of an eternally changing universe or of an eternally changing God.

Yet the notion of a totally unchanging God is just as indigestible. Given that the changing universe must have had a beginning, its origin requires some explanation, and the handiest is that of a pre-existing, creative Something, the only alternative being an

incredibly productive Nothing. But how could this unchanging "God" (which in this context is merely another name for "Something") engage in a creative act without undergoing any sort of change, such as the change from inactivity to activity?

Perhaps the most illuminating attempt at an explanation so far has been Fechner's analogy with universal gravity, which seems to effect changes without being affected itself. The trouble is, as Einstein's later efforts suggest, that we don't know much more about gravity than we do about God. Indeed, we have yet to understand space and time, matter and energy, our fellow human beings, or even ourselves. For all that we have learned about the universe, we obviously have not the faintest idea how much more we do not know. We can hardly claim to know how the universe works, much less why. How then can we expect to understand Anything That Might Have Created It? It seems likely, even inevitable, that our comprehension of a divine nature would have to be something like a tapeworm's comprehension of human nature. Indeed, this seems to be what Ahura Mazda was trying to suggest to the inquisitive Zoroaster and what the Lord was trying to get across to poor Job.

An Accommodation

Accepting our inability to solve the problem may suggest a way of living with it. Those who do not want to live with it are free to find refuge in unrestrained credulity (accepting without question, for instance, an infinitely powerful Creator who literally rested on the seventh day), in adamant incredulity (how can we be so sure about those 32 great-great-great-grandparents?), or in any other haven in between. If the Flat Earth Society is still active even after the Apollo flights, if hundreds of poor souls could behold the spark of divinity in the Rev. Jim Jones of Guyana, if some of those health-insurance ads in Sunday supplements can actually sell policies, then obviously there always have been and will be people who will believe, or disbelieve, absolutely anything regardless of evidence. For the vast majority of us, indeed, religious beliefs and behavior can be readily interpreted simply in terms of conditioned

reflexes. Can be, have been, and generally are. And certainly not without reason.

Conditioned reflexes, however — including such habits as our automatically speaking of the sun's "rising" in the east and referring to God as "he" — need not be the final determinant in such human activities as considering the likelihood of a heliocentric solar system, calculating the value of pi, or exploring the possibility of a timeless but active God. If anything, summary dismissals of that possibility are easier to explain in terms of reflexes than are the sustained efforts through the centuries to explore it. The dismissals arise out of an intuitive, absolute, openly irrational, highly emotional faith, in Anything or Nothing, which can be communicated only to those who, for whatever reason, are predisposed to embrace it. Even when based on diametrically opposed opinions, such dismissals display, on both sides, the rigid, impenetrable conviction symptomatic of closed minds. Pro or con, right or wrong, such faith is immune to doubt, impervious to evidence, inaccessible to reason, and intellectually incommunicable. Can anyone imagine Luther and Nietzsche, for example, engaging in a dispassionate, rational dialogue? Is there any practical way of handling summary dismissals other than summarily dismissing them?

The exploratory effort, in contrast, relies on a shared acceptance of open-ended inquiry as a means of increasing our knowledge and understanding, however frustrating it may be at times. It aims at opening doors, not closing them. It prefers light to heat, evidence to dogma, and dialogue to sermon. Although it has never provided, and surely never could provide, the kind of self-inspired, subjective certitude that Kierkegaard apparently found in his "leap of faith," it can at least offer a level of confidence which others, like Mill and James, have found high enough to meet the demands of decisions, if not of ecstasies.

Careful thinkers who were also careful believers concluded long before Mill and James that human reason is a pretty feeble instrument for producing portraits of God in any reliable detail. Several thinkers (Maimonides, Aquinas, Nicholas of Cusa, Schleiermacher) maintained that reason can reveal only some of the things that God is *not*, and nothing of what he *is*. Thoroughly

reliable in this limited function, it can be expected to point out the Gordian knot of God's timeless activity but not to cut through it. And it can also be expected to recognize its own limitations.

This recognition can lead, and has led, to a distinction between a flat contradiction and a paradox. Just as the contradictions between macrophysics and microphysics are being accommodated with the growth in understanding of the two very different contexts, so those between faith and reason have emerged as paradoxes from a consideration of the different levels involved. This in turn has led to an acceptance of the role of analogy in depicting divinity in human terms. Any activity of God must be of an order much different from what we are acquainted with in our limited experience. In addition, timelessness is utterly outside our experience, so that the most that we can "divine" through reason is that God cannot be both active and timeless as those words and concepts are understood within our experience of the world about us. One can see why Aquinas and others have been so negative about our mental capabilities and why Augustine was so uncertain about our grasp of "time."

Thus the reliance on analogy. If the only rationally possible deity must be both active and timeless, and if activity as we know it can occur only in time as we know it, then in this instance there must be something we do not know about one or the other, or both, that makes timeless activity possible. Since this activity cannot come solely from matter as we know it, the idea of an *immaterial* deity arose early and has stubbornly persisted throughout human history. This negative notion has been combined with that of positive activity into the idea of a "spiritual" Being—a resort to analogy, using a word for physical breath as a metaphor connoting something beyond the physical. Today, at our current level of knowledge, or ignorance, we might consider one aspect of an eternal spiritual Power as the universal energy which, although manifested in perceptible change, may itself be unchanging (and imperceptible). If this is the sort of portrait that some of the process theologians have in mind, they could be making a very significant contribution.

If we can detect energy only indirectly, through its effects, we have some reason to ask why, analogically, the same cannot be

true of God. There is a difference, true enough, that a modern Aristotle might hasten to point out: the energy we discern behind universal activity shows no particular talent for organization. Although its intensively coagulated forms, characterized as possessing mass, display a stunning variety of organization from the simple to the incredibly complex—the human brain is now estimated to contain a quarter of a million miles of intricate circuitry—it has been discovered also in the formless, entropic state of universal blackbody radiation. The analogy may hold up well enough as an illustration of our second-hand information, but it limps in its failure to recognize organization as coming from a Mind.

And so one analogy was rescued by another. The idea of an invisible Power having visible effects is quite evidently about as old as mankind, and so is the idea of mind, of intelligence, as the source of organization. In human experience the outstanding creative characteristic of human intelligence is, and surely always has been, that of organizing materials and ideas into better forms—more efficient, more pleasing, stronger, faster, easier, whatever, as illustrated, say, by the current popularity of the wristwatch over the sundial. Since our observation of animal intelligence generally indicates, by analogy, a gradual ascent from simple to complex, with mankind at the apex, what could be more natural than to extrapolate the analogy, à la Teilhard, to an ultimate Intelligence responsible for the intricate organization of the world?

A Necessary Evil

But this analogy in turn created a problem, a severe problem that may have done more to discredit God than all others put together. Human intelligence, unavoidably if grudgingly perceived as highly fallible, is not expected to organize anything flawlessly. But its *goal* is flawless organization, and the analogy demands that a totally infallible Intelligence must organize everything flawlessly. Yet as we look about us and behold all those glaring flaws, the analogy seems about as reliable as Humpty-Dumpty's opinion on equilibrium.

This is "the problem of evil," a difficulty so important and so knotty that a separate intellectual discipline has grown up around it with the significant designation of "theodicy," connoting a "judgment of God." As could be expected, it has provoked extreme reactions at both ends of the conjectural spectrum, with countless gradations in between. At one end Calvin's uninhibited faith portrayed a God of infinite love malevolent enough to condemn, quite arbitrarily, great multitudes to endless torment; at the other Stendahl, grimly surveying the evil in the world, asserted bitterly that the only excuse for God is that he does not exist. Although some people can live with such propositions, neither has ever achieved much intellectual respectability. Calvin's view combines incompatibles, and Stendahl's simply drops us back to square one, like a zoologist denying that there could ever be such a ridiculous thing as a camel.

Other thinkers have displayed a more serious, problem-solving attitude. Zoroaster posited a pseudodivine principle of evil. Jesus, somewhat similarly but in line with Hebrew monotheism, spoke of the prince of this world. Augustine developed Plotinus' idea of physical evil as merely a negation of good and blamed moral evil on human free will, and Aquinas added that God is responsible for the freedom but not for the evil arising from it. Ramanuja seems to have shared the Augustinian view, and Sankara carried the idea a bit further, characterizing all evil as illusory. Spinoza considered evil to be real but its positive aspect to be illusory. Leibniz thought it real enough, under any aspect, but not nearly so real nor so abundant as the good. Hume and Schopenhauer agreed largely with Stendahl, looking on evil as testimony to the malice or incompetence of a thoroughly implausible God. Mill and James concluded that God must be finite, having only limited power. Teilhard thought evil inevitable until the world reached the Omega Point. And so on.

"Good" and "evil" have such a range of meanings in different contexts that it may be well to turn to another nomenclature. If the universe shows enough organization to suggest a Supreme Intelligence behind it (or within, above, around, or before it), we can legitimately resort to order and disorder as the basic ingredients of good and evil, as when we speak of physical and mental illnesses

as disorders. Order in this sense is dynamic as well as static, functional as well as structural, applying as much to the operation of a human brain's electrical impulses, for instance, as to the condition of its circuitry.

If both order and change are essential to the universe, how could it ever be absolutely perfect? Since it could not then become more perfect, any changes would have to make it less than absolutely perfect. If an absolutely perfect universe is thus intrinsically impossible, no such universe could have been created by anyone, not even by Anyone. The *degree* of imperfection is open to criticism, but that would be true of *any* imperfection, especially in the absence of any means of comparison. (If the world were "almost" perfect, surely we would be chronically petulant about it.) What criterion can one use for deploring the particular state of imperfection? Hume's criterion seems to have been Hume: like a candidate for political office, *he* could have handled things much better. His measuring stick is a popular one, especially with the "Here, let me show you how" type of personality.

But it's not very useful for the rest of us. We do not really know enough about disorder to make any irrevocable judgments, although we are learning more about it every day. We think of human pain, for instance, as a disorder, in the sense of both an abnormality and a dysfunction, yet the still young scientific study of pain is revealing how useful most of it is, how much of it is "in the mind," how differently it affects different individuals, including martyrs and practicing masochists, and how differently it affects the same individual at different times. Any apparently useless pain, such as that of terminal cancer, is of course open to question, such as may be asked about its influence on the discovery of endomorphins—but to *question*, not necessarily to casual condemnation based on atheistic presuppositions.

One of those presuppositions is that there can be only material values—Hume's pleasure principle, for instance— but, if there is an immaterial Creator and Sustainer, pain may have a spiritual value, if only in the sense that without any human pain there could be no Mother Teresa. If the disorder of random, "harmful" cosmic radiation can be responsible for the orderly progress of evolution, for the survival of the fittest, how can we know, as Teilhard might

ask, that the progress can't reach beyond the physical? Who has such a grasp of all reality that he can reasonably extract a dogma of divine incompetence simply from the disorder in the world? If there is anything to progress in human understanding, surely such a judgment is very premature.

If animal and human suffering seem, at least tentatively, consonant with a divine creation, what of the divine suffering revealed in scriptures, especially in the Bible? If Jesus shared in the infinite happiness of God, could he really have suffered during those three brutal days in Jerusalem? Is this a flat contradiction or another of those elusive paradoxes?

If God somehow participating in a changing world is a flat contradiction, then God suffering is a flat contradiction. But if God participates, then surely he must suffer in some extraordinary sense — perhaps, as Fechner proposed, the suffering is not his own but ours, a sympathy born of his love for the creatures he made in his image. However elusive the paradox, anyone who accepts the basic reliability of divine revelation can see Christ's suffering as a supreme instance of that love. If a Supreme Intelligence has undertaken to communicate to his more or less intelligent creatures, he needn't, and couldn't possibly, have told us absolutely everything. The strongest argument against his existence would be our total comprehension.

In the physical sciences, ideas are subject to empirical testing. Einstein's hypothesis of the effects of gravitational force on electromagnetic radiation was hard to understand and was received skeptically until it was confirmed by the observable bending of starlight that grazed by the sun during the famous solar eclipse of 1919. Similarly, his inordinately elusive theory concerning the effects of velocity and gravity on the passage of time, or on objects in time, has received some confirmation in the slowing of atomic clocks being carried by satellites. Such testing can lift a hypothesis to the exalted status of theory or even of a generally accepted conclusion; it can also send a generally accepted conclusion back to the drawing boards or even to the scrap heap. Word portraits of God, however, have not been subject to any such restraint, and this lack of inhibition has permitted the survival of some pretty gamy

speculation. The only restraining factor has been common sense, which usually proves quite uncommon outside one's own tight circle of opinion. And so hypotheses about the Creator, unlike those about creation, have never been tried in a universally recognized court of appeal.

Amid all the uncertainty rational creatures might be expected to practice the most scrupulous and benign tolerance of others' portraits of God. But rationality has regularly succumbed to the cohesiveness and uniformity demanded by the group, especially against other groups. Portraits of God—of the tranquil Buddha, of the loving Father, whatever—have been used to justify the caste, the rack and stake, the genocidal crusade, inquisitorial terror, and generally a kind of divine right of arrogance. Since the Enlightenment, and its slow spread from West to East, the minority view in favor of tolerance has obviously gained ground in certain areas. Although the progress has been agonizingly slow and bigotry has continued to find other easy outlets in political, social, athletic and other activities, the primacy of love in the history of God may yet gain the recognition that it has always deserved.

Bibliography

Entries are numbered for reference in the Index

Principal Sources

1. Baum, Archie J. *The World's Living Religions*. New York: Dell, 1971.
2. Ballou, Robert O. *A Portable World Bible*. New York: Viking, 1944.
3. Copleston, Frederick. *A History of Philosophy*. Garden City, N.Y.: Doubleday, 1963.
4. Hartshorne, Charles. *Philosophers Speak of God*. Chicago: University of Chicago Press, 1953.
5. Haydon, Albert E. *Biography of the Gods*. New York: Macmillan, 1942.
6. Thomas, George F. *Religious Philosophies of the West*. New York: Scribner's, 1965.

Other Sources

7. Adler, Mortimer. *How to Think About God: A Guide for the 20th-Century Pagan*. New York: Macmillan, 1980.
8. Angeles, Peter A. *The Problem of God*. Buffalo: Prometheus Books, 1980.
9. Aron, Robert. *The God of the Beginnings*. New York: Morrow, 1966.
10. Balentine, Samuel E. *The Hidden God: The Hiding of the Face of God in the Old Testament*. New York: Oxford University Press, 1983.
11. Bennett, Curtis. *God as Form: Essays in Greek Theology*. Albany: State University of New York Press, 1976.
12. Bonansea, Bernardino M. *God and Atheism: A Philosophical Approach to*

175

the Problem of God. Washington, DC: Catholic University of America Press, 1976.

13. Brightman, Edgar S. *The Problem of God.* New York: AMS Press, 1979.

14. Clemen, Carl C. *Religions of the World, Their Nature and Their History.* New York: Harcourt, 1931.

15. Cleve, Felix M. *The Philosophy of Anaxagoras.* New York: King's Crown Press, 1949.

16. Collins, James D. *God in Modern Philosophy.* Chicago: Regnery, 1967.

17. Dewey, John. *A Common Faith.* New Haven: Yale University Press, 1934.

18. Edwards, Jonathan. *Works.* New York: Leavitt, Trow & Co., 1848.

19. Fozdar, Jamshed. *The God of Buddha.* New York: Asia Publishing Co., 1973.

20. Freddoso, Alfred J. (ed.). *The Existence and Nature of God.* Notre Dame, Indiana: University of Notre Dame Press, 1983.

21. Gaskin, J. C. A. *The Quest for Eternity: An Outline of the Philosophy of Religion.* Notre Dame, Indiana: University of Notre Dame Press, 1983.

22. Gerrish, B. A. *Grace and Reason: A Study in the Theology of Luther.* Oxford, England: Clarendon Press, 1962.

23. Grisez, Germain G. *Beyond the New Theism: A Philosophy of Religion.* Notre Dame, Indiana: University of Notre Dame Press, 1975.

24. Harris, Erdman. *God's Image and Man's Imagination.* New York: Scribner's, 1959.

25. Hartshorne, Charles. *Omnipotence and Other Theological Mistakes.* Albany: State of New York University Press, 1984.

26. Hick, John. *Evil and the God of Love.* New York: Harper, 1966.

27. _____ (ed.). *The Existence of God.* New York: Macmillan, 1964.

28. Holbrook, Clyde A. *The Iconoclastic Deity: Biblical Images of God.* Lewisburg, Pennsylvania: Bucknell University Press, 1984.

29. Hopkins, Jasper. *A Concise Introduction to the Philosophy of Nicholas of Cusa.* Minneapolis: University of Minnesota, 1978.

30. Horden, William. *A Layman's Guide to Protestant Theology.* New York: Macmillan, 1955.

31. James, William. *The Varieties of Religious Experience.* New York: Random House, 1902.

32. Kaufman, Walter (ed.). *The Portable Nietzsche.* New York: Viking, 1954.

33. Klubertanz, George P. *Being and God.* New York: Appleton-Century-Crofts, 1963.

34. Kung, Hans. *Does God Exist? An Answer for Today*. New York: Vintage Books, 1981.
35. Mackie, John L. *The Miracle of Theism*. New York: Oxford University Press, 1982.
36. Marcus Aurelius. *The Meditations*. (Trans. by George Long.) New York: A. L. Burt Co., n.d.
37. Matczak, Sevastian A. *Karl Barth on God*. New York: St. Paul Publications, 1962.
38. Murchland, Bernard (ed.) *The Meaning of the Death of God*. New York: Random House, 1967.
39. Picht, Werner. *The Life and Thought of Albert Schweitzer*. New York: Harper & Row, 1965.
40. Pike, Nelson (ed.). *God and Evil*. Englewood Cliffs, New Jersey: Prentice-Hall, 1964.
41. Rahner, Karl. *Foundations of Christian Faith*. (Trans. by William V. Dych.) New York: Seabury Press, 1978.
42. Sikes, J. G. *Peter Abailard*. Cambridge, England: Cambridge University Press, 1932.
43. Teilhard de Chardin, Pierre. (Jean-Pierre Demoulin, ed.) *Let Me Explain*. New York: Harper & Row, 1970.
44. Walker, Williston. *John Calvin*. New York: Schocken Books, 1969.
45. Ward, Keith. *The Concept of God*. New York: St. Martin's Press, 1974.
46. Watts, Alan. *The Supreme Identity*. New York: Random House, 1950.
47. Wheelwright, Philip E. *Heraclitus*. New Jersey: Princeton University Press, 1959.

Encyclopedias

Dictionary of the History of Ideas. New York: Scribner's, 1973.
Encyclopedia of Religion and Ethics. New York: Scribner's, 1951.
New Catholic Encyclopedia. New York: McGraw-Hill, 1967.
The New Schaff-Herzog Encyclopedia of Religious Knowledge. New York: Funk & Wagnalls, 1909.

Index

The numbers in parentheses refer to entries in the Bibliography